IMAGES
of America

PEABODY'S
LEATHER INDUSTRY

IMAGES
of America

PEABODY'S
LEATHER INDUSTRY

Ted Quinn

ARCADIA
PUBLISHING

Published by Arcadia Publishing
Charleston SC, Chicago IL, Portsmouth NH, San Francisco CA

Printed in the United States of America

Library of Congress Catalog Card Number: 2007937344

For all general information contact Arcadia Publishing at:
Telephone 843-853-2070
Fax 843-853-0044
E-mail sales@arcadiapublishing.com
For customer service and orders:
Toll-Free 1-888-313-2665

Visit us on the Internet at www.arcadiapublishing.com

*Dedicated to all the leather workers of the world,
with special thoughts to the Peabody leather workers,
for all their work in building this country into
the great and diverse nation that it is today.*

CONTENTS

ACKNOWLEDGMENTS

A special thanks goes out to my loving and very supportive wife, Jill; my three beautiful and understanding daughters, Kayla, Anna, and Lilah; to my mother and father, Ed and Niki; my brother Brian and sisters, Karen and Andrea; and to all those who helped, inspired, and put up with me during this arduous albeit satisfying project.

I would also like to express my gratitude to all the individuals, groups and organizations that helped me and graciously shared their stories and images: the George Peabody House Museum, Peabody Historical Society, Peabody Leatherworkers Museum, Peabody Essex Museum, Peabody Institute Library, H. Ray Wallman, and Mary Coughlin.

INTRODUCTION

In the book of Genesis it is said that the Lord fashioned tunics of skin and clothed Adam and Eve. The Romans clad their soldiers with leather for protection and the countless other uses of leather are too numerous to mention. Leather has indeed enjoyed a stellar history and Peabody, Massachusetts, has been a dominating footnote to its enduring legacy.

Peabody was destined to be the hub of the leather industry. It was an ideal place for the tanning business because of all the clean and abundant water in the three brooks—the Goldwaithe, the Proctor, and the Strongwater—that ran into the millpond, to the North River, and eventually into the Atlantic Ocean. It was all this water that earned Peabody, which was originally part of Salem, the name Brooksby.

If you lived in Peabody, Massachusetts, someone in your family probably worked in one of the many leather factories scattered out over the downtown area near the square. If you lived near Peabody it is quite probable that you knew someone who worked in the leather factories of Peabody, and if you lived anywhere else in the world you must have heard about Peabody, because Peabody was at one time the leather capital of the world.

To prove Peabody's importance to leather I pose the question: How many cities or towns can claim that a single industry, in that city or town, has had enough companies in the industry so that every letter in the alphabet has been used at least once as the first letter in those company's names. Not many I imagine. Peabody, however, can claim that fun fact.

As the leather business expanded, so did the town, and so did the need for more help. The leather industry rode the immigrant waves of the 19th and 20th centuries and it was just perfect.

There was the A. B. Clark Company on Union Street that produced 72,000 finished sheep skins a week while in operation during 1905–1916. It was the largest sheep skin manufacturer in the world and Alexander B. Clark, the owner of the company, was dubbed the "Sheepskin King." There was the L. B. Southwick Company, founded by Louis B. Southwick and Josiah B. Thomas, and at its height of operation, the Southwick Company had, on 10 acres of land, a large wooden building consisting of 150,000 square feet and brick factories with over 100,000 square feet of floor space. There was Morrill leather, Carr leather, Cox leather, and Korn leather. There was Vaughn Calfskin, National Calfskin, and U.S. Pigskin. There was Strauss tanning, Verza tanning, Kirstein tanning, and the list went on. The first development of tanning machinery was established in Peabody and the Vaughn, Corwin, and Turner companies were some of the largest manufacturers in that business.

By the end of the 19th century, Peabody was well established as the major player in the leather tanning industry; however, it was in 1894 that Peabody was crowned the king with the

formation of the A. C. Lawrence Leather Company. Arthur C. Lawrence came to Peabody in 1894 and at that time the total valuation of manufactured products in Peabody was $6 million and 10 years later in 1905 it had increased to $20 million. In 1909, just 15 years after arriving in Peabody, the A. C. Lawrence Leather Company employed well over 2,000 employees. The A. C. Lawrence Company's patent leather division, located on Pulaski Street off the Waters River, was the largest in the world as well.

Peabody enjoyed its status in the world, but as they say, all good things must come to an end; with harsh environmental laws and the outsourcing of cheap labor to third world countries the leather industry, the once bread and butter for Peabody, started to wane. The once flourishing businesses were now all but abandoned, and some were actually fully abandoned. They were the fodder for many a conflagration. The 1960s and 1970s saw some of the biggest and most destructive fires with factory after factory laid to ashes.

Unfortunately I cannot create the sounds and smells of the bustling leather industry in Peabody; however, my hope is that this book, with its photographic images and narratives, will help you understand the history, the process, and the rise and fall of the leather tanning industry. It will also put faces behind the leather belts and shoes that some of you wear and the purses and wallets that you might own. So sit back in a nice smooth, comfortable leather chair, if you have one, and enjoy.

One

EARLY TANNERS

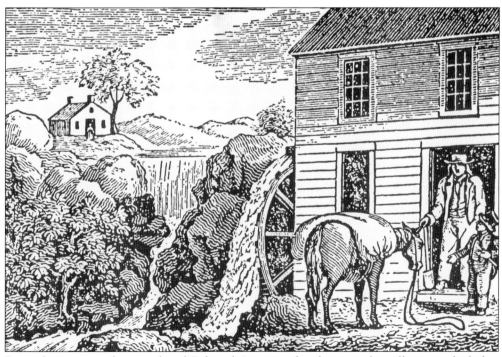

Since there are no photographs of Colonial America, this drawing of a mill is typical of what they looked like in 17th- and 18th-century Peabody. Owing to the copious amounts of unspoiled, crystal clear water, it was the ideal location for tanning leather, as the American Indians had long before discovered.

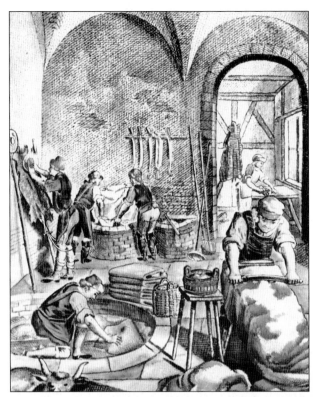

These German prints depict curriers and tanners of 17th-century Europe. They demonstrate the men at work, however it does not show the mess that was the scene at the tanneries and cannot provide the odiferous permeation of smells that enveloped the tanneries.

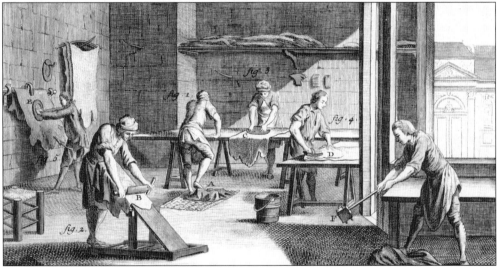

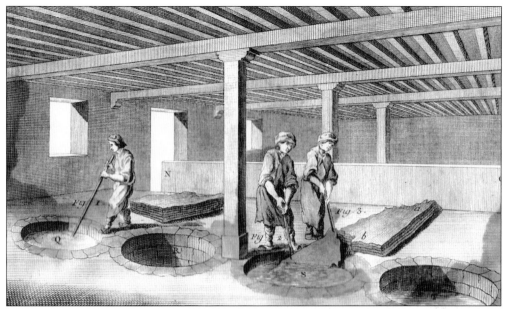

The tanners, using hooks or tongs, pull the hides from the tan vats in the top image, and the morocco dressers in the bottom image are using tubs to color the skins.

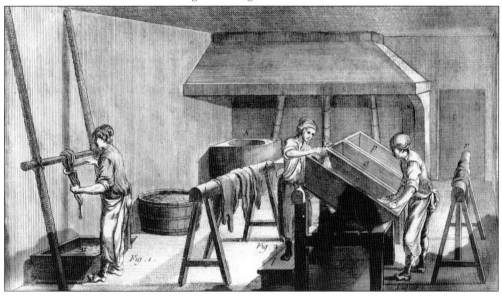

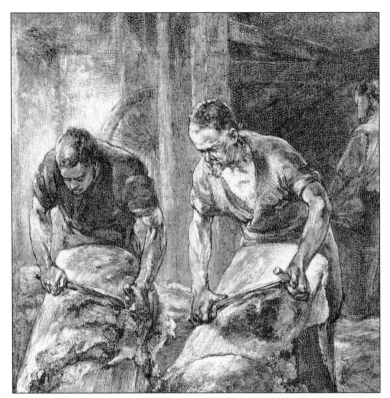

The hides were brought in to the hide or beam house, usually in the basement, because the basements were usually a little cooler, but on a hot day the smell of the flesh, along with the maggots and flies, was horrendous. Hides were placed on slanted curved wooden tables, or beams, and the men would use curved knives to separate the hair and dermis from the actual hide. This was called de-fleshing.

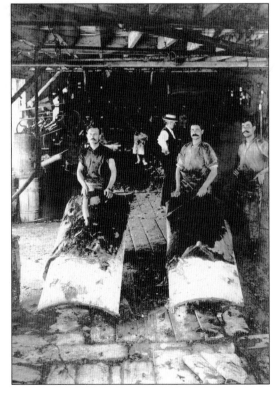

Working "over the beam," these three men, only identified in the original picture as Big Greek, Greek M., and Greek D., worked in the J. A. Lord Jr. leather shop in 1906. This business, started by his father John A. Lord in 1838, burned in 1880, was rebuilt by J. A. Lord, suffered a fire again 1888, and was rebuilt again by J. A. Lord Jr. and was owned by him until at least June 15, 1906, when this picture was taken.

12

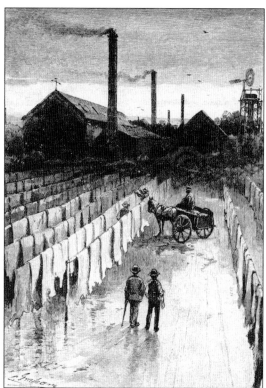

Early tanners used the air and sun to dry out the hides. They were called tan yards. They were as large as depicted at right or as small as the back yard of someone's house, as shown below. It all depended upon the tanners business. Drying lofts and heated conveyers were used later to speed up the process.

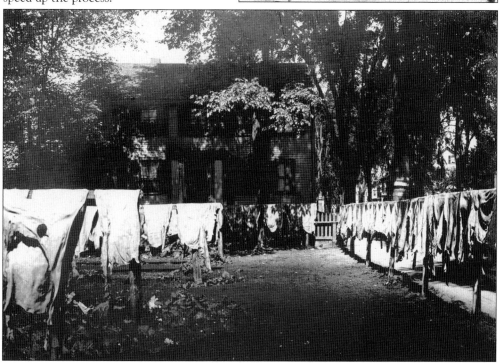

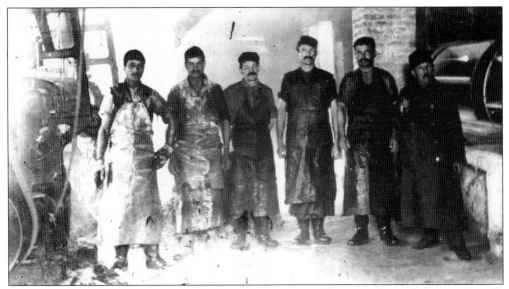

These men, usually immigrants from Europe, were the backbone of the workforce and made Peabody the diverse community that it has become.

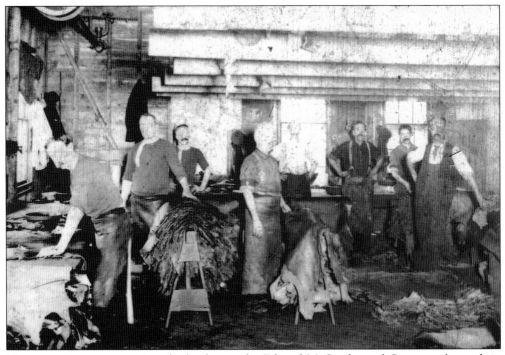

Here men are seen seasoning the leather at the Edward McCarthy and Company located on 4 Railroad Avenue.

Two

THE PROCESS

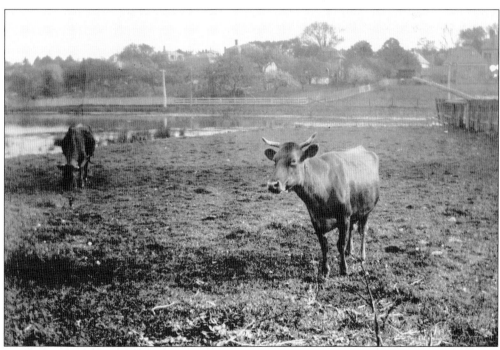

The very first step on the leather tanning process is the acquisition of the sheep or cow hide. These bovines, photographed in 1899, lived within feet of the A. C. Lawrence Leather Company. They probably kept a watchful eye on the tannery at the east end of the pond. They were probably quite safe though because the hides used by the Lawrence company came from the Midwest and mostly from Swift and Company, a major stockholder in the Lawrence company. This chapter's images, mostly from the A. C. Lawrence Leather Company, shows the process of tanning cowhide. The Lawrence company tanned and finished cowhide and sheepskin. The sheepskin was shipped to them from Australia and New Zealand and was already de-haired and pickled. The cowhides were shipped to them in a cured or salted state, and that is where the journey begins.

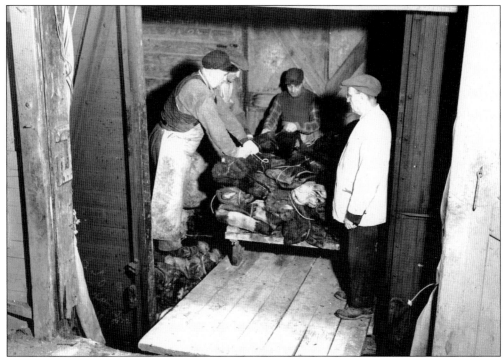

The first stage of tanning was the receiving of the green salt cured hides. The hides traveled by train from the Midwest and were unloaded into the beam house in packs weighing around 1,500 pounds. The hides were then taken to a storage site as they were received, usually in the basement of the same building because of the coolness.

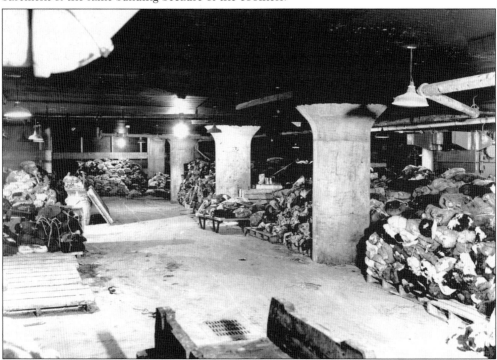

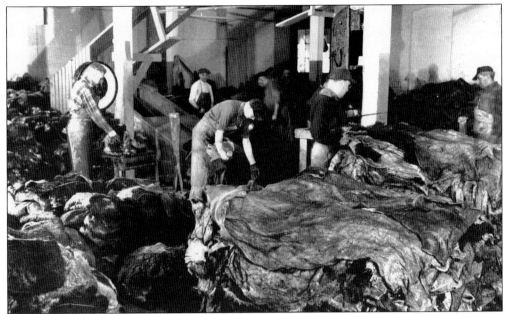

The selecting of the leather was done in the hide cellars. The hides were handpicked and sorted by size and quality. To produce high-quality leather, the raw material needed to be high quality as well. Weighing and trimming was done here and the leather usually received an 8-to-10-digit stamp on the leg part of the hide, the precursor to the bar coding of today. This process was also referred to as horsing-up.

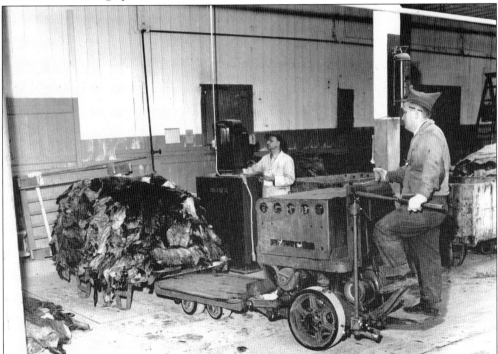

After the pack had been weighed, around 1,500 pounds, this electric fork lift was used to transport the pack of leather to the wash wheels.

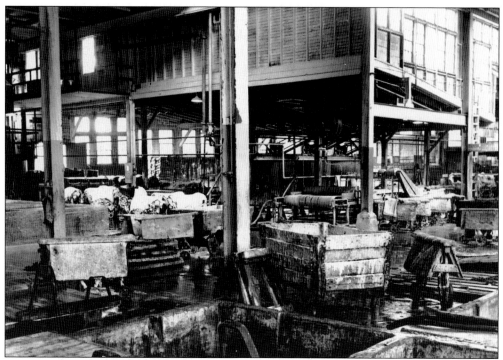

This is a general view of the beam house at the A. C. Lawrence plant. This is where the hides would receive their first wash.

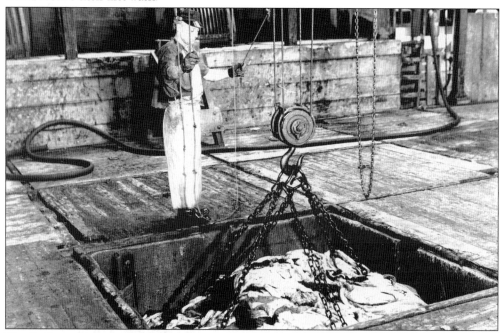

The Endicott Street and Berry Street facility used the bark tanning method and a crane was used to raise and lower the pack to and from the tan pit. This process was the old method of tanning in which the hides would soak in a pit with tan bark, similar to bark mulch. This process, which took months, was sped up with the use of chrome salts, which only took a day.

Once the hides were received, selected, and graded they were soaked in a soak or wash wheel, commonly referred to as a wet wheel. This was done in big vats with revolving paddles or in big wooden drums with a constant flow of clean water. This process not only cleaned the hide of debris such as salt, blood, dirt, and manure, but it also helped to de-hair it as well. The hides were washed until they were as soft and clean as when they were taken from the animals back. Depending on the condition of the hide, due to the different forms of curing, the procedure to expedite the process would be different. This was usually done in the basement due to the copious amount of water that was needed.

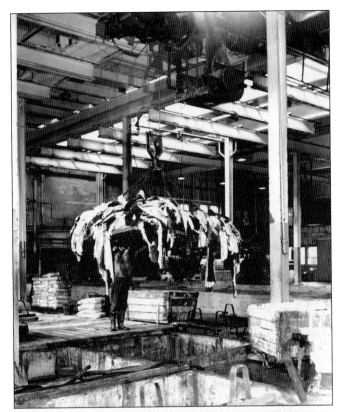

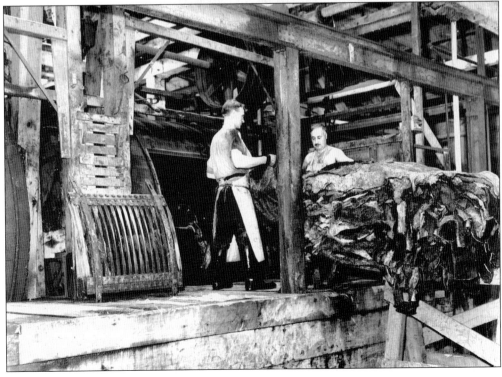

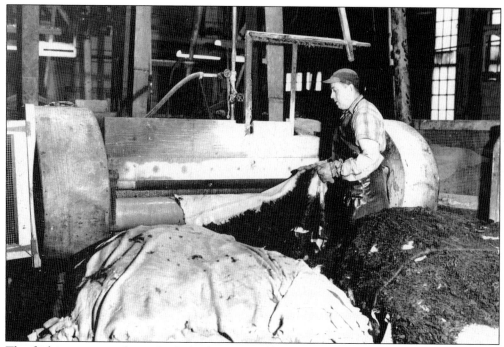

The fleshing process places the hides between rollers with sharp spiral knives. These knives revolve at a high rate of speed and the skins are forced and drawn against it by friction. The excess of fat and flesh is cleaned off and leaves a clean surface for the chemical treatment to follow.

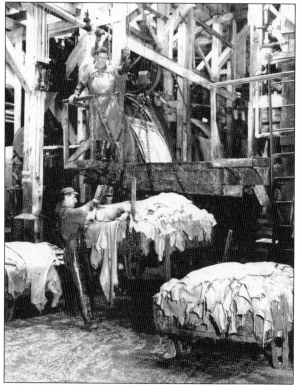

These men are using a crane to raise the pack to a wet wheel for the next step in the process, depilation.

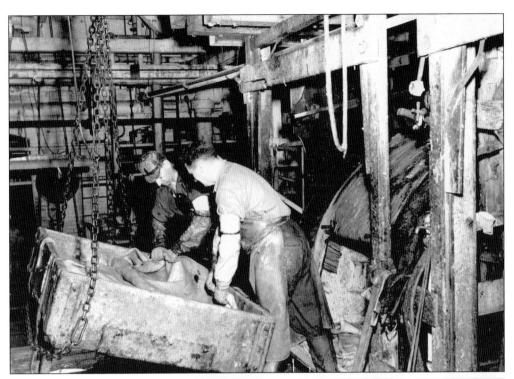

Depilation is the process where the remaining hair and epidermis are removed. The hides are placed in a paddle vat, or drum, containing a lime liquor mix, along with some sodium sulfide. This process may take two or three days. The process causes the hides to swell and the fiber bundles to open up, as well as the pores, and allows the easy penetration of the liquors subsequently used in the tanning process. The chemicals act as a kind of hair remover, such as Nair, and cause saponification and then loosening of the foundation upon which the hair roots are embedded.

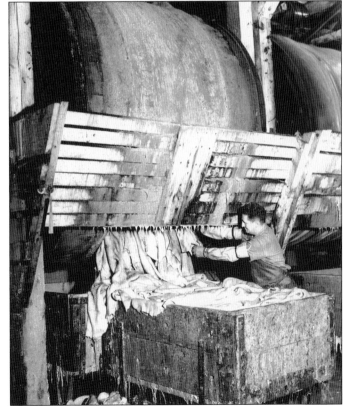

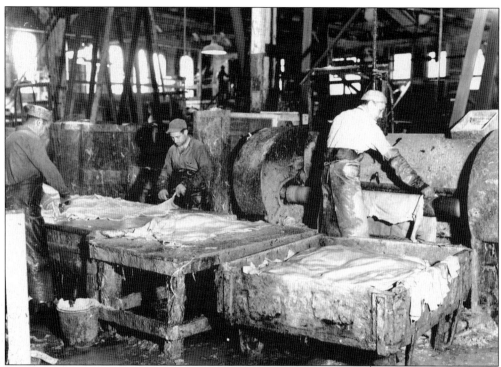

As if the fleshing, depilation, and chemical process were not enough, now comes some more of the unhairing process. This is done with an unhairing machine, similar to a fleshing machine, with the exception that the knives are blunt instead of sharp. Scudding machines are also employed to remove the remaining hair and epidermis.

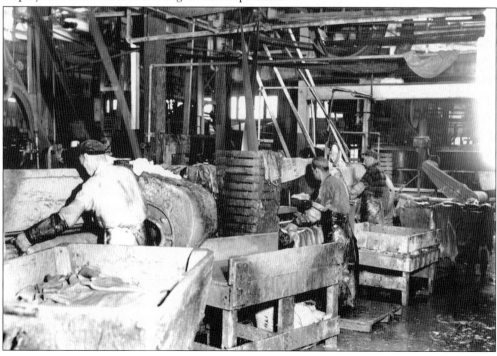

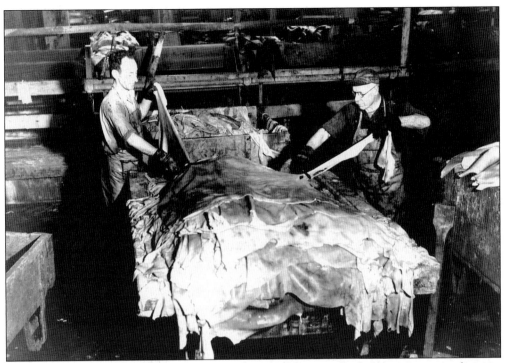

These men are trimming the limed splits, above, and then it is back for some more unhairing, as seen below.

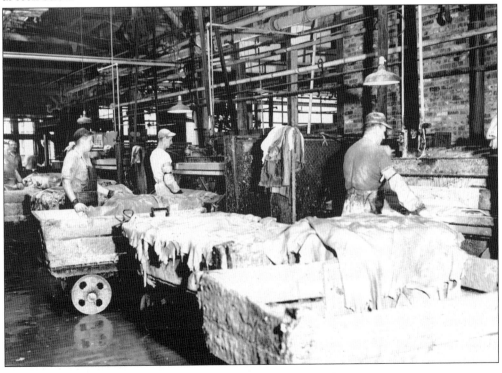

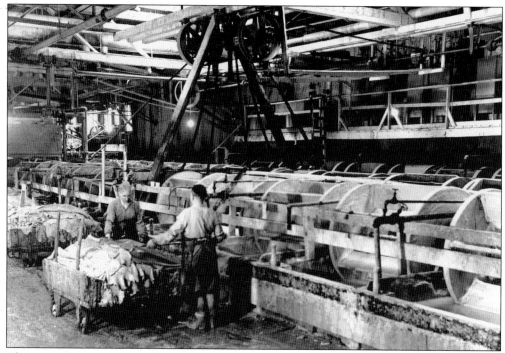

The unswelling process is called bating. This process, now using chemicals and enzymes, was once conducted by using dog, hen, and pigeon manure. The hides are soaked in the solution and the paddle rotates.

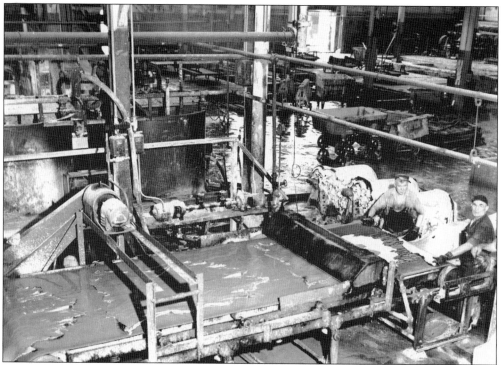

Another method is to apply sulfide paste by way of a conveyor, shown above.

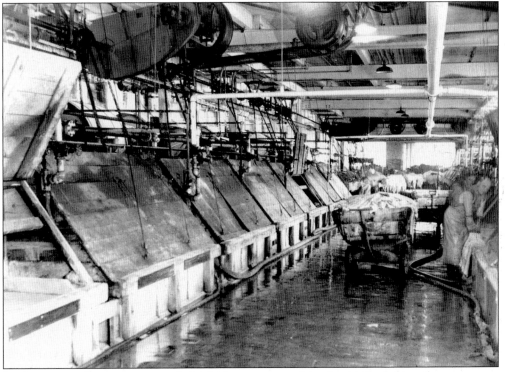

In the image above is a view of the bating room, and in the image below, these men are transferring the bated stock to the pickling vats.

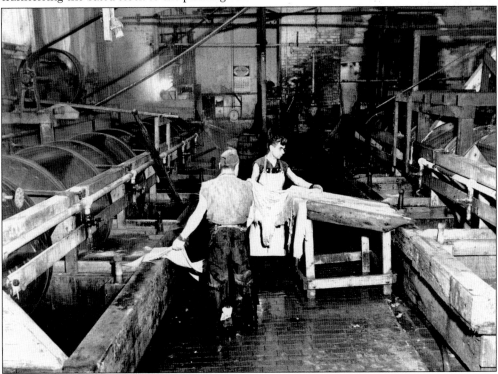

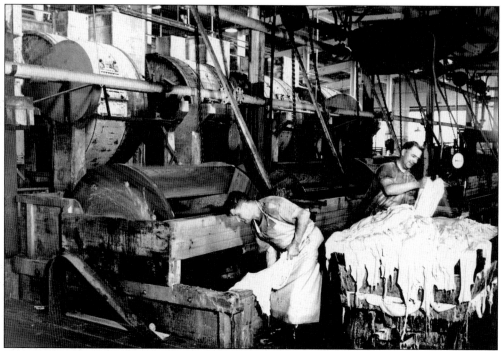

In the image above the men are loading the machines that are called the pickle paddle. Note the wooden wheel, or paddles, similar to a paddle boat. In the image below they are removing the stock from the pickle paddles. Now that the hides are pickled they can stay in that state for quite some time.

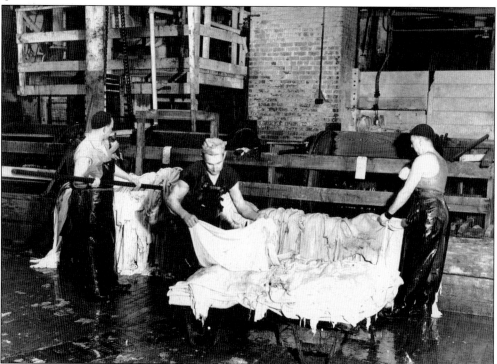

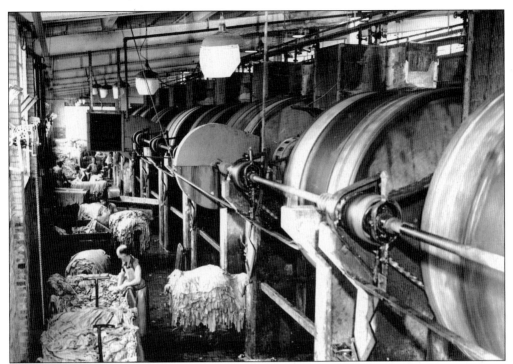

This image highlights the vastness with a view of a battery of tanning wheels. As stated prior, these wheels were usually in the basement or ground level due to the copious amount of water needed and the need to drain them.

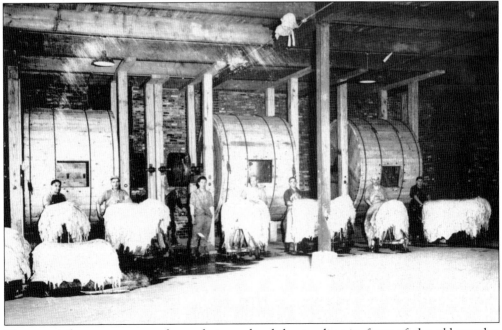

The men of yesteryear pose for a photograph while standing in front of the old wooden tanning wheels.

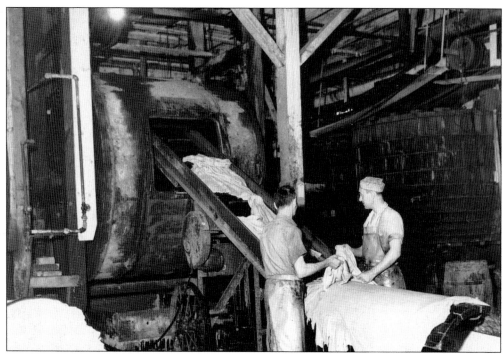

The chrome tanning wet wheel shown here utilizes a conveyor to load the wheel with the untanned hides.

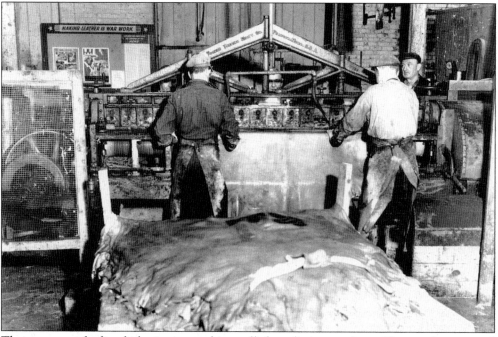

These men are feeding hides into a machine called a splitting machine. This machine is used when the hides are too thick and it becomes necessary to separate the hides into splits. The machine cuts the hides lengthwise into two pieces having the same surface area but thinner than the original hide.

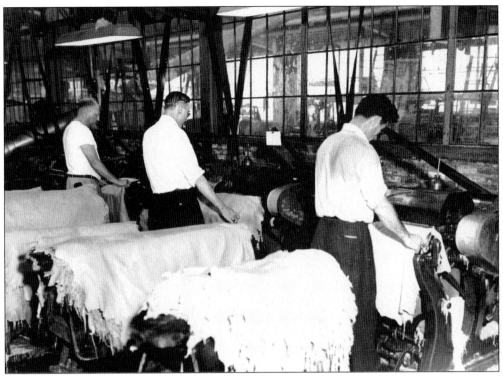

These men are operating shaving machines, which smooth off the flesh side of the skin making the entire hide, or skin, uniformly thick.

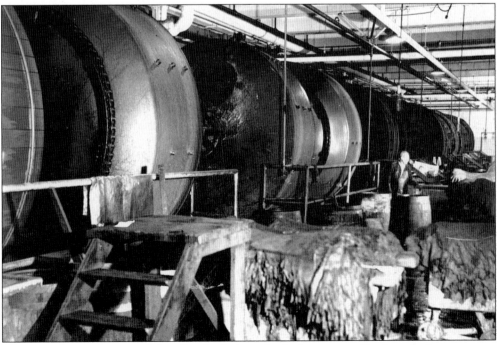

This view shows a battery of glass-lined coloring wheels that are used in the coloring process.

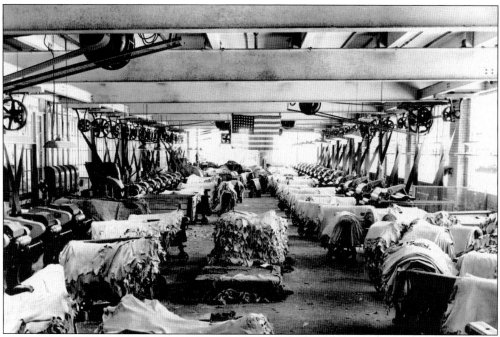

This view of the blue sort and shaving room, with a 48-star Stars and Stripes hanging from the ceiling, must have been taking at break time. Notice the skin all horsed up and ready for shaving.

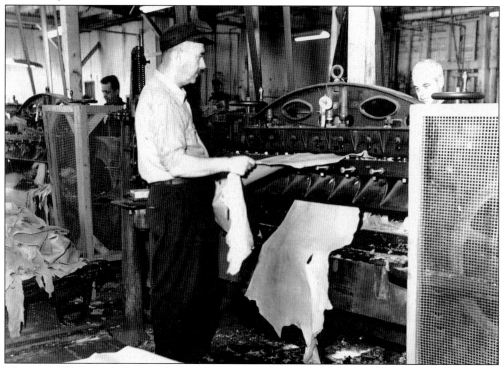

The men here are splitting hides that are thru blue, which means they are ready for finish work.

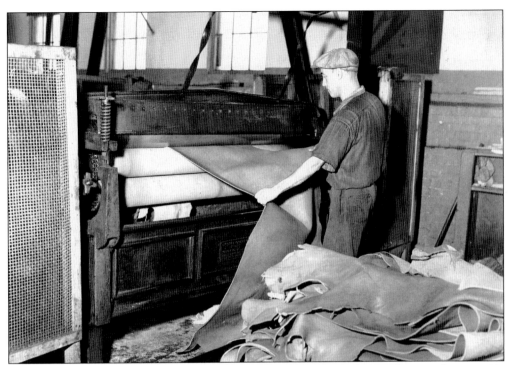

This machine is a Baker-Layton putting-out machine, or setting-out machine, and it removes excess water before shaving.

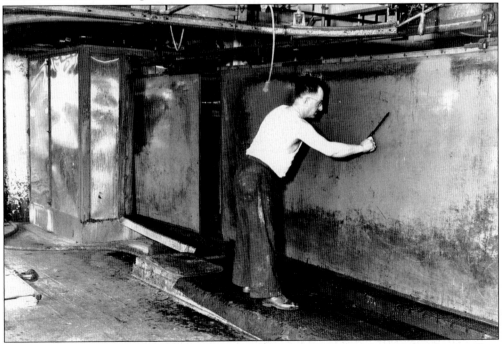

Prior to putting the skins on a pasting board and through the dryers they need to have a clean surface. Once this is accomplished paste is sprayed on the board and the skin is ready to be pasted on the board.

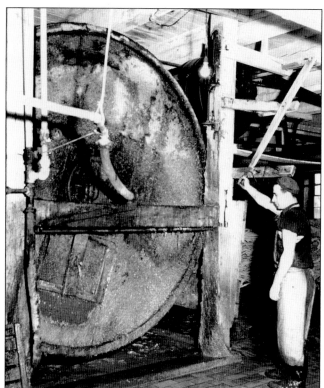

Like the soak wheels and tanning wheels, the color wheels are usually made of the same material. The skins are put in the wheels with hot water and dye is added through a trunnion in the middle of the wheel.

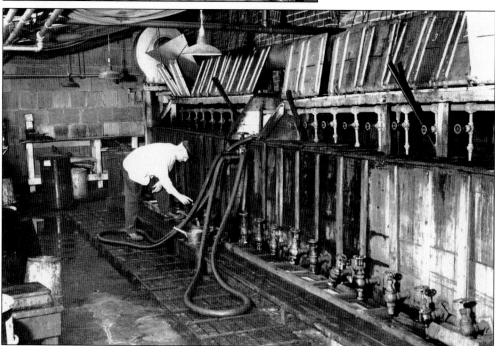

An emulsion of oil commonly called fat liquor, which is a milky substance, is a combination of neatsfoot oil and sulfuric acid. Its purpose is to save the hides from getting dried out. This man is checking out the valves in the dye and fat liquor feed room.

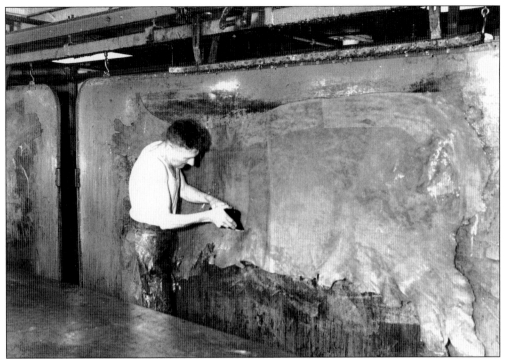

Using a slicker, this man, pictured above, is pasting a hide to a pasting board, called vertical pasting, that will travel through a air dyer, while the bottom images shows a man moving the board to a dryer room.

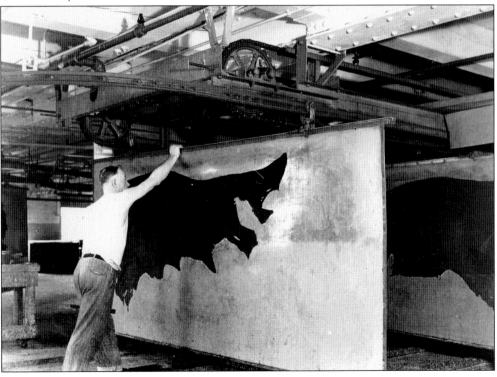

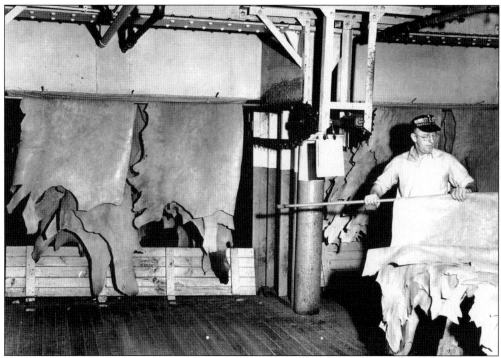

This man's job is to remove the skins from those wooden dowels after the hides have been run through the air dryers.

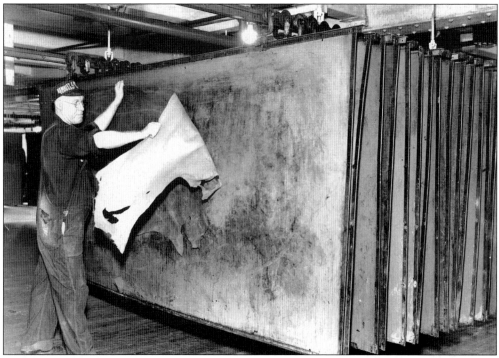

Removing the skin from the pasting board after going through the dryer room is called stripping the splits from the boards.

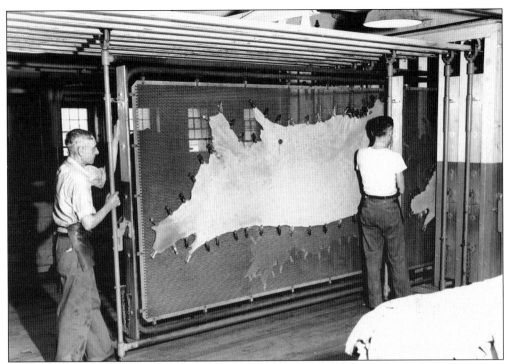

This metal mesh frame is being pushed into a Proctor and Schwartz drier. These skins were toggled, or clipped, to the screen and then put in the dryer room.

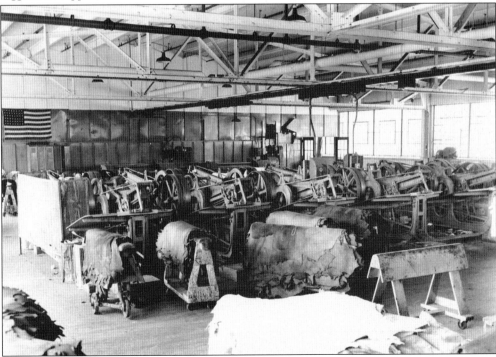

This view of one of the staking rooms shows the hides set upon wooden horses ready for the next operation.

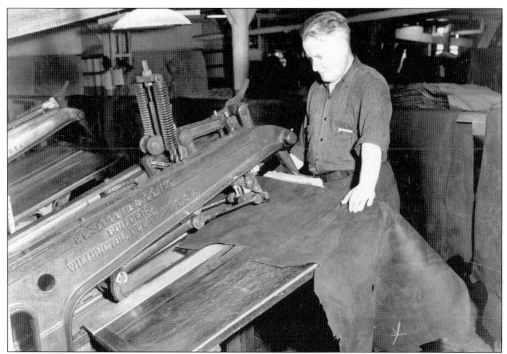

This image shows an example of a staking machine. A staking machine looks like a big mechanical arm. It grabs the leather and stretches and softens it. It was sometimes referred to as a belly staker because the men would use their bellies to hold onto the leather.

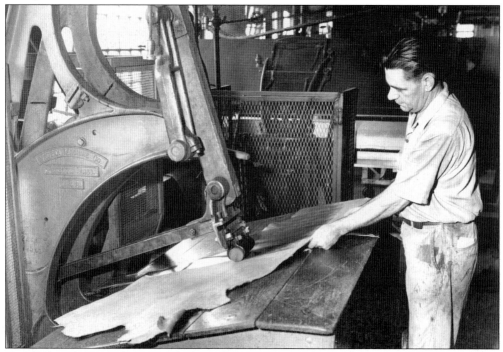

Another machine similar to a staking machine is called a glazer, which used a rolling glass tube to shine-up or glaze the leather.

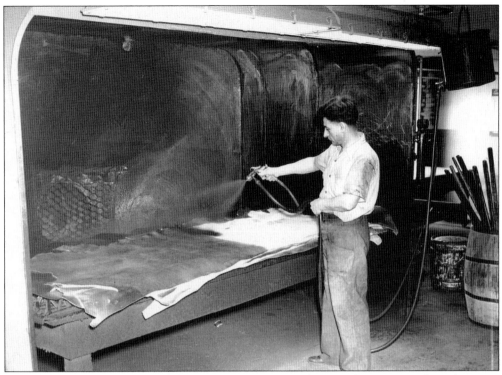

Some of the leather was sprayed by hand, like the image above, and some went through a spray booth, like the one below.

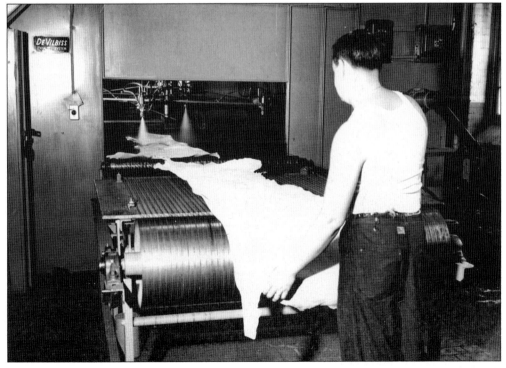

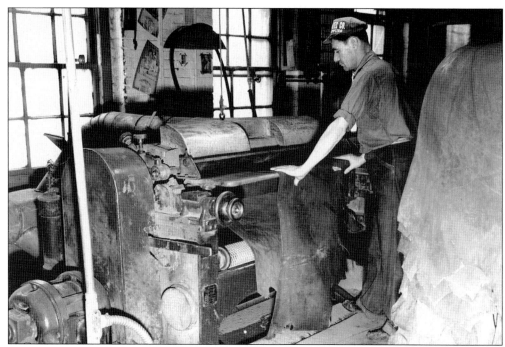

Next comes the buffing process. Some skins have natural healed scratches or parasitic damage in the grain. It is sometimes necessary to buff out some of these. The buffing machine uses sanding cylinders covered with a special abrasive material similar to sandpaper. The light sanding leaves a clean smooth surface. The buffing machine in the image above is a Curtin-Hebert buffing machine and the one in the image below is a high back buffer.

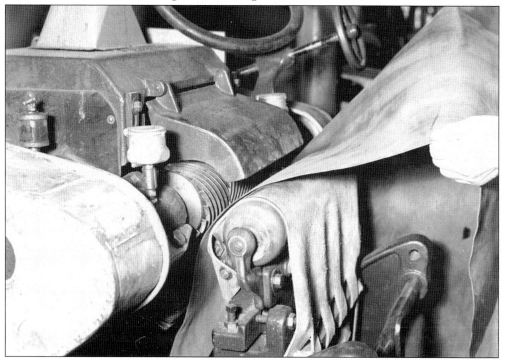

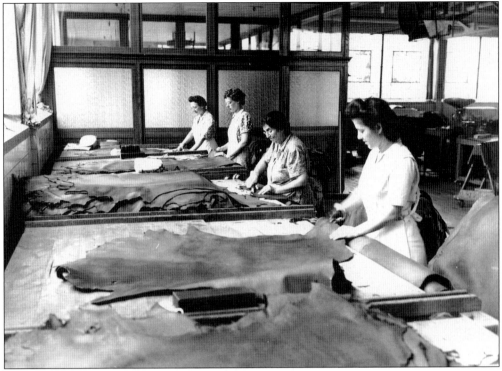

Trimming is done to rid the leather of any lingering, non-salable pieces of leather.

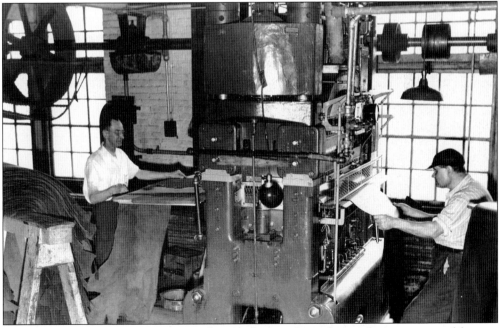

The plating, or embossing, process is done with a machine that applies pressure and heat to the splits. This process will either smooth out the leather or apply a pattern or texture in it, whatever the buyer's preference was. Ernest Woeffel was the first in the area to bring this process to Peabody and designed many patterns at his embossing and plating company

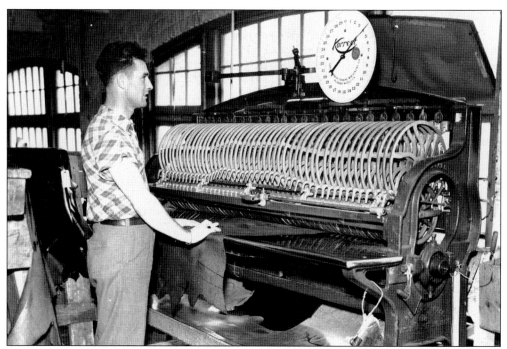

Before packing and shipment the leather is sized and measured to determine its cost. The measuring machine used in the measuring of leather is a very unique machine. It measures the square feet of something that is not square. Some places still measure leather with these machines, but with new technology the leather is usually measuring with photocell, laser, and computers. The machine in the image below has two men working at it. The man on the right is washing the hide of any paste that may still be on the hide. It is then sent to the packing and shipping department where it is prepared to be shipped to a buyer.

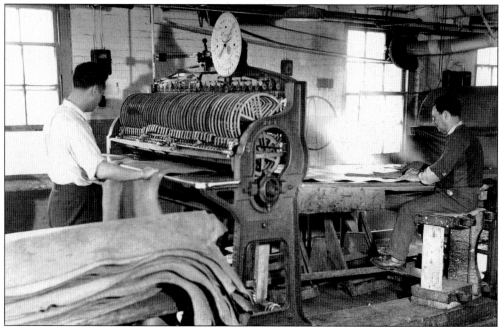

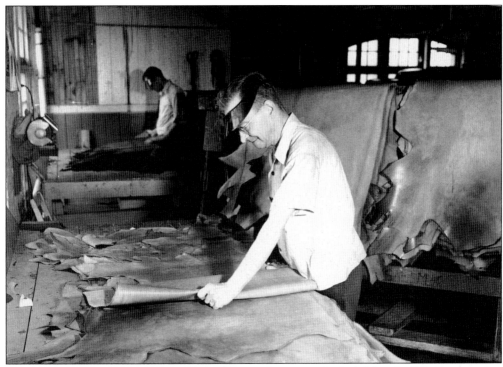

Now comes the final inspection. Some leather may have to go back and be rebuffed or trimmed to be made salable. Once the inspector is satisfied someone will roll the leather into rolls of 12 or so.

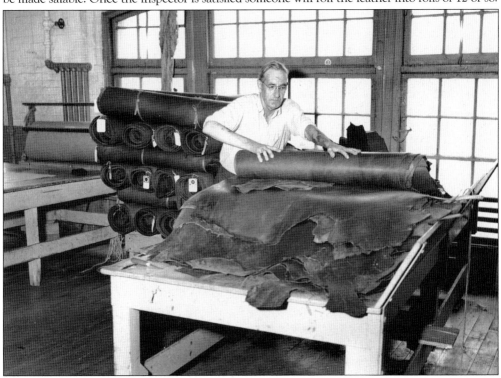

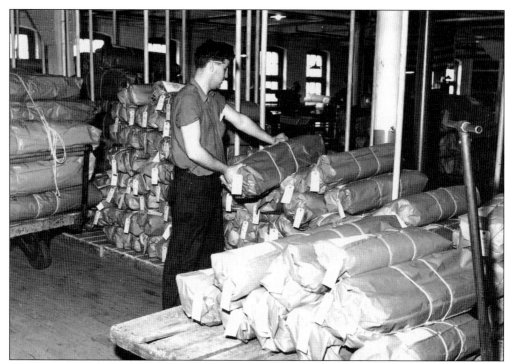

Once the leather is rolled, it is then packed, put in paper rolls, tied up, then it is ready for shipment.

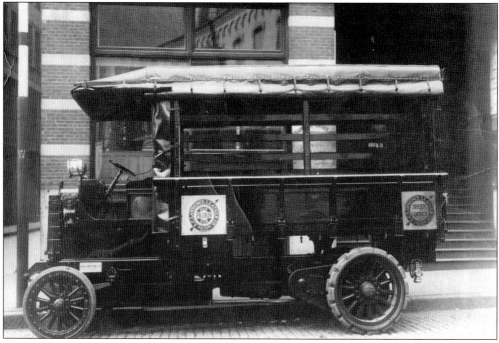

Once the order is processed, trucks, like this A. C. Lawrence company truck that is parked out in front of the A. C. Lawrence Leather Company's Boston office, ship the leather to its destination.

Three

TANNERY TOWN

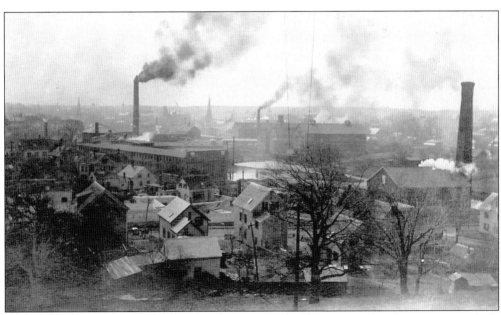

Facing southeast from Buxton's Hill, a bird's-eye view of downtown Peabody and Crowninshield Pond can be seen. With A. C. Lawrence Leather Company in the foreground, the picture portrays a typical view of a late-19th- and 20th-century dark and smoky industrial town.

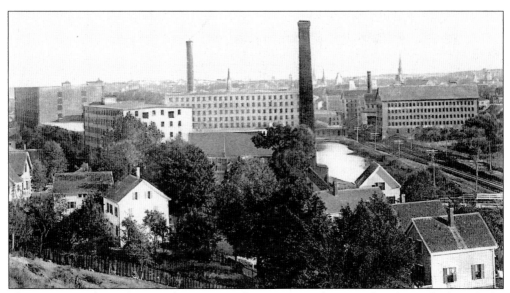

This image, similar to the preceding picture, shows a postcard view with a cleaner look, with the skyline speckled with smokestacks and steeples.

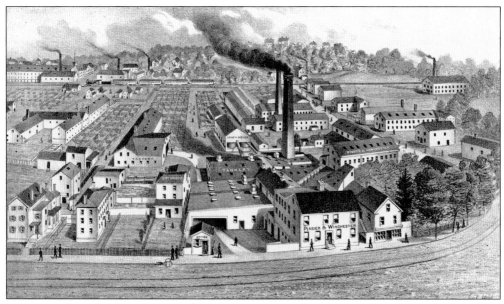

Facing north, with Main Street in the foreground, near the corner of Grove Street, this image from the 19th century shows the sprawling Pinder and Winchester tannery.

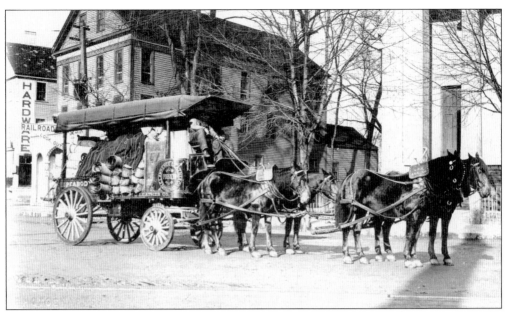

The drivers of the horse-drawn wagons were called curriers or teamsters. They cared for the horses like they were their own. They would pick up the hides from the railcars and transport them to the leather shop for tanning. At other times they would bring the tanned hides to another shop for one of the many other processes. A. C. Lawrence Leather Company had the biggest fleet being the biggest company in Peabody with numerous plants and locations. These wagons were quite possibly manufactured in Peabody by one of the many carriage makers. The driver of the wagon in the bottom image is Samuel Buxton.

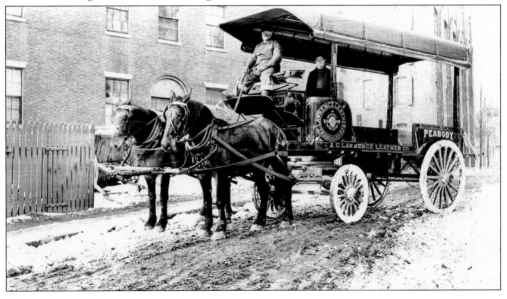

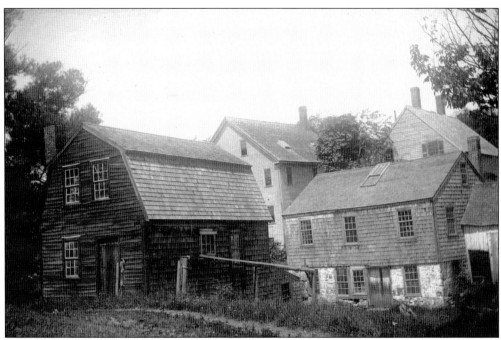

These old-looking houses were actually small tanneries and a sole factory, nestled between Aborn and Holten Streets, alongside of Goldthwaite Brook. Access to the buildings was gained by Pleasant Street. After years of abuse by vandals, the property finally succumbed to a fire in 1995.

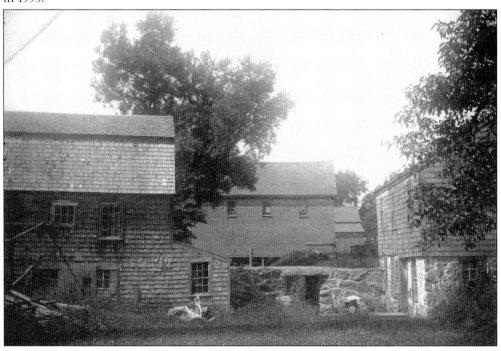

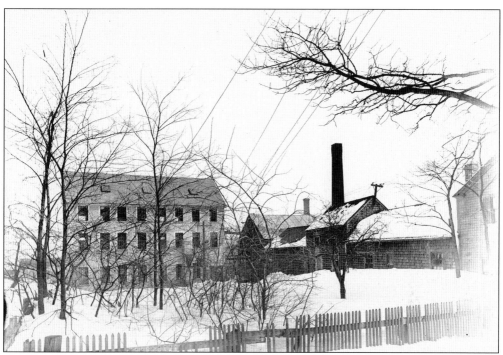

Strauss and Hygrade Tanning owned by the Strauss family had shops in Salem and Peabody. The image above was located at 145–147 Lowell Street in Peabody. It was an old factory that dated back to the Civil War. It is now the location of the Kingdom Hall of the Jehovah Witness. The image below is Hygrade, located in Salem. The bales of burlap, on the right of the image, are quite possibly scraps of leather.

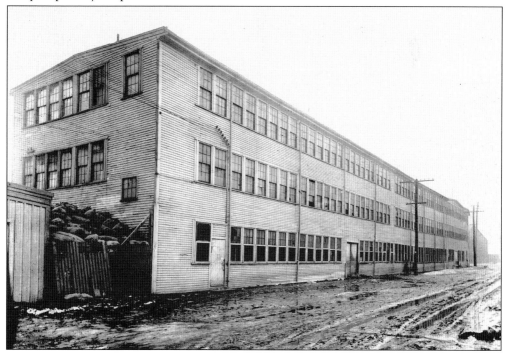

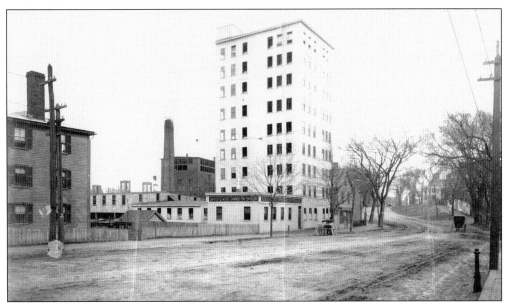

The United States Pig Skin factory, which was a nine-story building, was located on lower Main Street near the corner of Grove Street, now Howley Street. The company made leather for, among other things, footballs. This picture was taken facing east toward Salem and shows the building at its prime. The building was occupied by the Winchester and Company, but has housed many other businesses throughout the years. It fell into disrepair and was later referred to as the "Leaning Tower of Peabody."

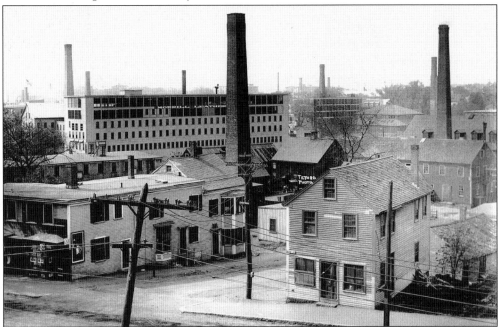

Facing northwest at the corner of Maine and Grove Streets, the Morrill leather factory, established in 1887 by Charles Morrill, is in the background, surrounded by numerous other tanneries, such as Pinder and Winchester. Pinder and Winchester was located on Main Street at the corner of Grove Street, now Howley Street, in an area that was also known as Poole's Hollow.

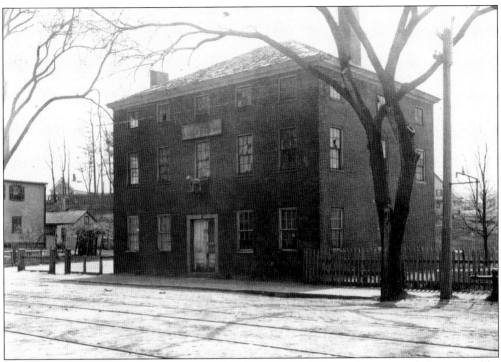

This three-story brick building was located at lower Main Street and was a wool shop owned by William Sutton. Noticed the lamb above the front door.

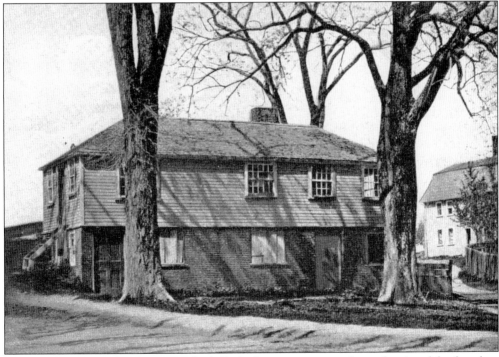

This building, located in Danvers, which Peabody was once part of, was the site of the first shoe shop in New England. The shoe industry worked side by side with the leather industry.

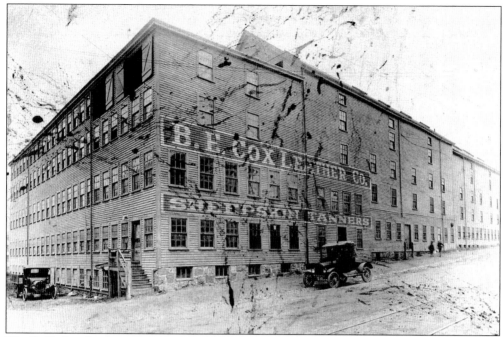

The B. E. Cox Leather Company, established in 1911 by Bertrand Cox, was located on Wallis Street, on the old Kraus Tanning Company lot, just up from the northwest corner of Walnut and Wallis Streets.

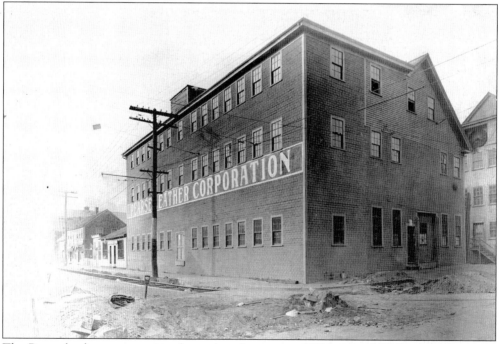

The Pearse leather company was located at the corner of Walnut and Wallis Streets. It later became home of the John Boyle Machine Company. The B. E. Cox factory can be seen at the far right of the image.

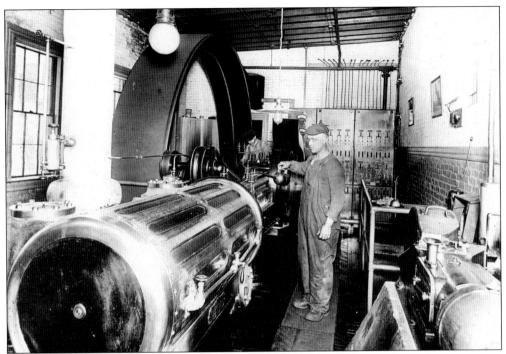

The boiler and engine rooms supplied the steam and electricity to the leather factories. Pictured here are some of the smaller ones. The image above is from the Pearse factory and the image below is from the L. B. Southwick factory with John Silva on the left, and Mr. Reid on the right.

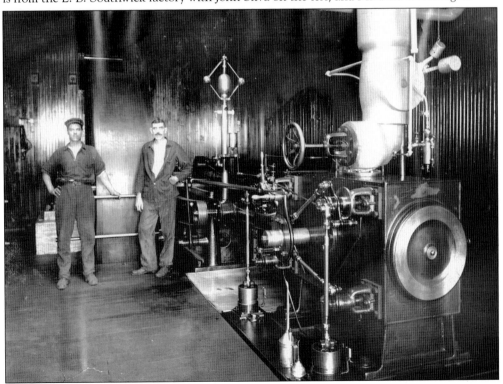

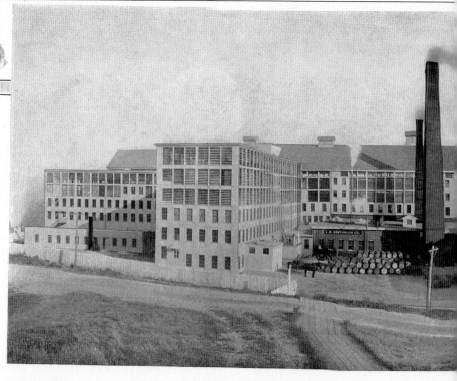

THE L. B. SOUTHWICK COM

SHOE LEATHERS

BLACK LININGS

A large line of glazed and dull black finishes.

COLORED LININGS

In various standard and specialized colors; also chrome tanned pearl and white.

BUTTON FLY REQUIREMENTS

Strongly tanned glazed and dull blacks; good feel and nicety of appearance. Universally satisfactory.

VELVET QUARTER LININGS

We maintain a stock of some twenty staple colors in ooze finish, which prevents slipping of the heel in oxfords and pumps.

LEATHER FOR OUTSIDES

Especially prepared mat topping of superior merit; also white and black (glazed and dull) chrome tanned leathers. Embossed leathers for slipper work.

BABIES' SOFT SOLE SHOES

Pinks, blues, creams, tans, reds, lavenders, etc., particularly adapted for this work.

105 BEDFORD STREET,

31 SPRUCE

Executive Offices and Selling Headquarters, 105

JOHN R. EVANS & CO.,
 PHILADELPHIA, PA., AND S

HARRY I. KIRK,
 CHICAGO, ILL.

P. A. HENRY,
 CINCINNATI, OHIO.

E. H. COWLES,
 ROCHESTER, N. Y.

A. J. & J. R. COOK,
 SAN FRANCISCO, CALL.

JOHN McENTYRE, LIMMITE
 MONTREAL, CANADA.

NICHOLSON, SONS & DANN
 GREAT BRITAIN, FRANCE & A

The Southwick family was one of the first tanners, and throughout Peabody's history, one of the largest families of tanners. This advertisement highlights the vastness of the

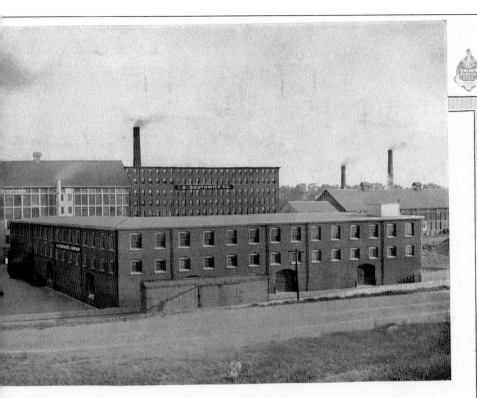

ANY, Tanneries, Peabody, Mass.

SPECIALTY LEATHERS

BELT LEATHERS	For making women's and men's belts; selected in proper lengths and substances.
HEAVY RUSSETS	Of good spread and plump substance in various finishes for pads, rice mill polishers, blacksmiths' aprons, etc.
BAGS AND POCKET BOOKS	Specially tanned and finished leathers; embossed or plain.
ART VELVET LEATHERS	An extensive line of fancy colors, carefully selected as to size and pattern.
PYROGRAPHIC WORK	Choice skins prepared for the various forms of burnt work, used for decorative purposes.
MOCCASIN LEATHERS	Heavy ooze finished stock in staple tan and brown colors for manufacturing moccasins.

L. B. Southwick factory on Foster Street. Part of the old brick tannery on Foster Street is a condominium complex.

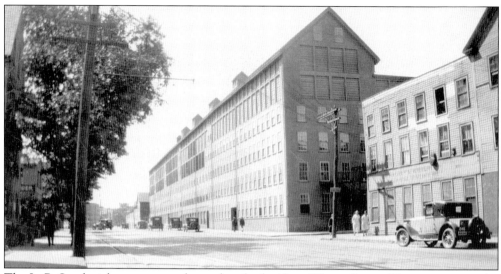

The L. B. Southwick tannery was located on both sides of Foster Street. This one was on the west side of Foster Street, at the corner of Franklin Street, in the 1920s.

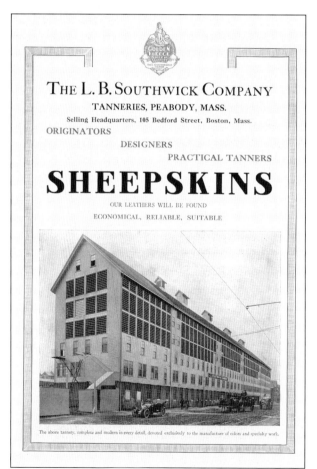

The L. B. Southwick leather company, one of the largest tanneries (second to A. C. Lawrence Leather Company) was co-owned by Louis B. Southwick and Josiah B. Thomas. This advertisement shows the opposite angle of the picture above.

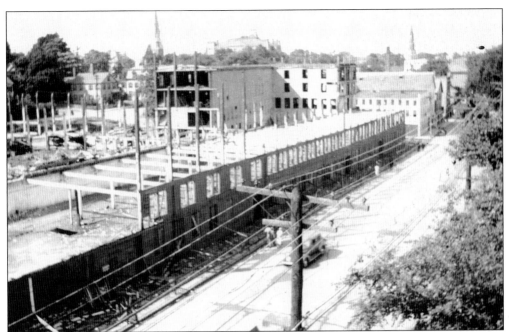

This view shows of one of the L. B. Southwick leather company buildings, on Foster and Franklin Streets, which was torn down in 1937 for nonpayment of taxes. This location is the site of the Metro bowling alley.

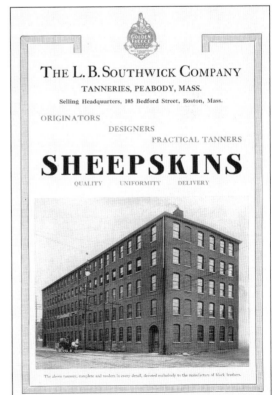

The view in this advertisement shows the L. B. Southwick factory that is on the east side of Foster Street, on the corner of Mason Street, and opposite of the Southwick plant from the opposite page.

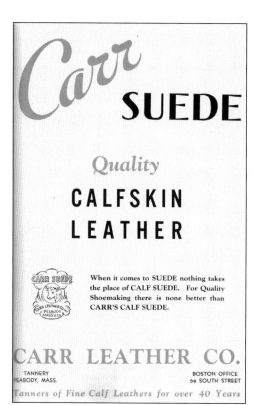

These advertisements can be found in many of the leather trade journals of the day. Carr Leather of Peabody, once owned by Felix and Arthur Carr, was another one of the big factories in town but moved to Lynn in the 1960s. The Carr family worked for, and eventually took over, Ideal Leather at 111 Foster Street. They started their business in 1894 in Salem and after the 1914 fire, moved to Peabody.

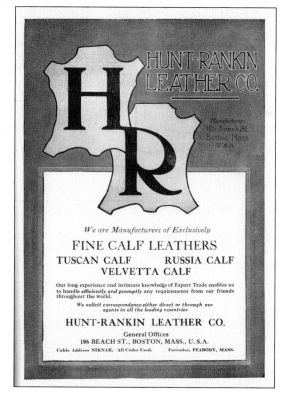

Hunt-Rankin Leather Company, established in 1907 by Herbert V. Hunt and Burt W. Rankin, was located on Summit Street in what is today the Summit Industrial Park. Its powerhouse and smokestack is all that remains of the original building.

Like many of the leather factories, American Hides and Leather Company, which had tanneries in Peabody, had its specialties like this one, Softan.

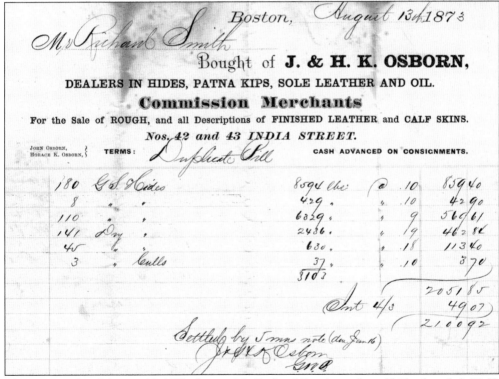

This receipt, dated August 13, 1873, shows a Mr. Richard Smith purchased hides from J. & H. K. Osborn totaling $2,100. Richard Smith and Sons operated a shop at 96 Foster Street for over five decades, from the 1830s through the 1890s.

The Korn Leather Company was established in 1900. It was originally located in Salem, however after the great Salem fire of 1914, it relocated, as did many leather shops, to Peabody. It was later incorporated in 1907 by Max Korn, as president and treasurer, and Rhoda Korn, as director, and was located at 16 and 18 Walnut Street until its ultimate demise in the 1960s.

The George W. Pepper Company, located at 9 Jacobs Street and on Elm Street, was home of the Gibraltar, a famous candy of its day. They also produced another product called Tittle's Leather Life. It was not only a waterproofing agent for leather goods, but it was also sold as prevention to coughs and colds, by keeping feet warm and dry.

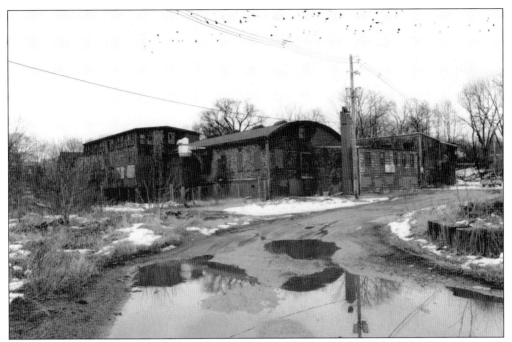

The Larrabee-Hingston company was a long-standing fixture in the Peabody leather industry. It was located along the North River at rear Howley Street, formerly Grove Street, where the new Stop-n-Shop supermarket is now located. It was a woodworking shop that specialized in tanning drums, wheelbarrows, and other tanning related wooden equipment.

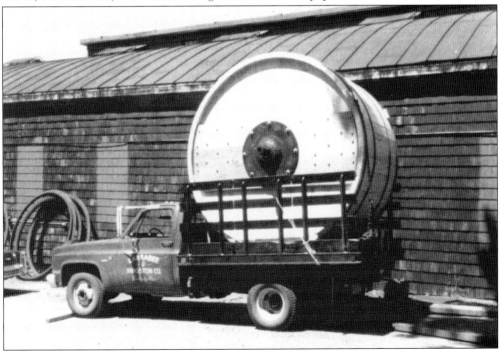

Another representation of the exemplary workmanship of the Larrabee-Hingston Company comes in the form of a finished tanning drum readied for shipment to one of the many tanneries.

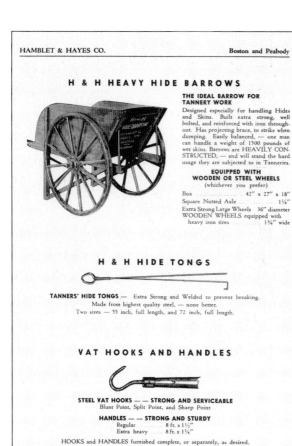

H & H HEAVY HIDE BARROWS

THE IDEAL BARROW FOR TANNERY WORK

Designed especially for handling Hides and Skins. Built extra strong, well bolted, and reinforced with iron throughout. Has projecting brace, to strike when dumping. Easily balanced, — one man can handle a weight of 1500 pounds of wet skins. Barrows are HEAVILY CONSTRUCTED, — and will stand the hard usage they are subjected to in Tanneries.

EQUIPPED WITH WOODEN OR STEEL WHEELS
(whichever you prefer)

Box	42" x 27" x 18"
Square Nutted Axle	1¼"
Extra Strong Large Wheels	36" diameter
WOODEN WHEELS equipped with heavy iron tires	1¾" wide

H & H HIDE TONGS

TANNERS' HIDE TONGS — Extra Strong and Welded to prevent breaking. Made from highest quality steel, — none better. Two sizes — 55 inch, full length, and 72 inch, full length.

VAT HOOKS AND HANDLES

STEEL VAT HOOKS — — STRONG AND SERVICEABLE
Blunt Point, Split Point, and Sharp Point

HANDLES — — STRONG AND STURDY

Regular	8 ft. x 1½"
Extra heavy	8 ft. x 1¾"

HOOKS and HANDLES furnished complete, or separately, as desired.

Hamblet and Hayes, located on Railroad Avenue, was another company that supplied the leather industry with the necessary equipment to operate. It supplied everything from wheelbarrows to hide tongs, to vat hooks and sandpaper for the buffing wheels.

EST 1897

HAMBLET & HAYES CO. · TANNERS SUPPLIES · CHEMICALS

Since 1897

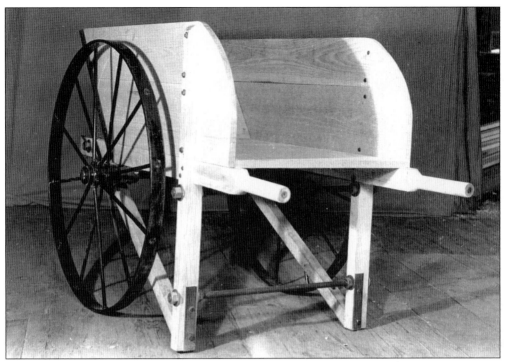

This well-constructed wooden wheelbarrow is a shining example of the fine craftsmanship of the Larrabee-Hingston company. The design of this wheelbarrow changed little over the years and was used heavily, as seen in other images, at the tanneries to transport skins from one process to another.

The Vaughn Machine Corporation was one of the tannery machine companies that supplied the tanneries with their tanning equipment.

An Aulson Machine Company advertisement claims that its staking machines eliminate tedious hand staking labor. Aulson was one the many companies in Peabody serving the leather companies as ancillary, or allied, businesses, such as Turner Tanning Machinery Company in the advertisement below.

Turner Tanning Machinery Company, originally a Boston concern, was incorporated in 1902 with a capital of $500,000. In 1904, the Turner company acquired a large portion of the leather machinery business from the Corwin Machine Company, located in South Peabody. Then in 1905, the company merged with the Vaughn-Rood Company, taking over its plant on Walnut Street, and moved the business from Boston to Peabody. It quickly became the leader in the tanning machinery business becoming the largest producer of leather machinery in the world. Turner also operated in Europe with plants in Leeds, England, Paris, France, and Frankfort, Germany. The original company, active in Peabody until 1962, was eventually taken over by the United Shoe Machinery Corporation. The Zolotas brothers of Peabody purchased the land in the 1960s.

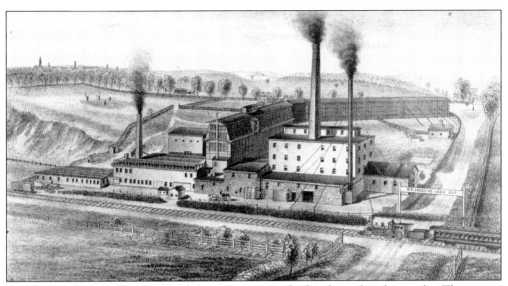

Another of the ancillary, or allied, businesses in Peabody where the glue works. There were many glue shops, such as, American, Sanger, Peabody, Upton, and Brown, as shown here in these advertisements.

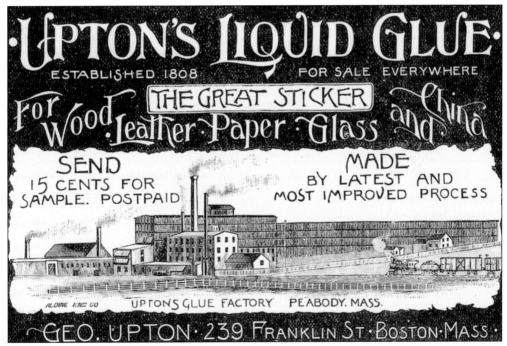

Here are some examples of the leather thickness gauges, or calipers, that were used to determine if the leather had the same thickness throughout. Many leather working tools, like these, were manufactured in the area including Peabody, which had numerous leather tool and machinery businesses.

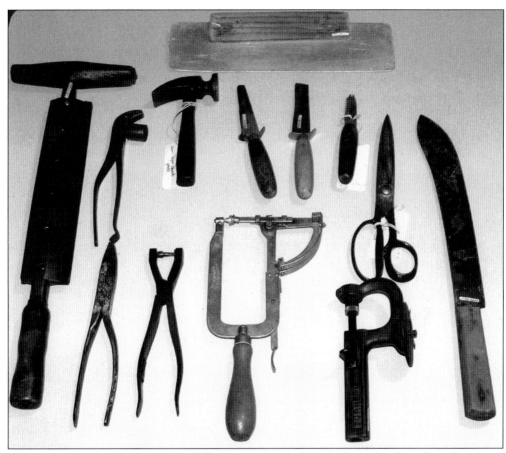

Tools of the trade; clockwise from left are some examples of a beam knife, tacking hammers, trimming knives, scissors, machete, leather thickness gauges, hole punches, and pliers. The bottom image shows a couple more examples of beaming knives.

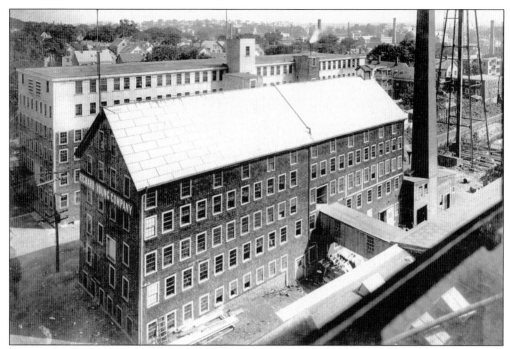

The Richard Young leather factory on Union Street took over the A. B. Clark factory in 1914. Richard Young started in New York in 1880 and incorporated in 1898. It operated five sheep leather tanneries and a calfskin tannery before going out of business in the 1950s. The Bay State chemical company took over the building, which later burned to the ground in 1995.

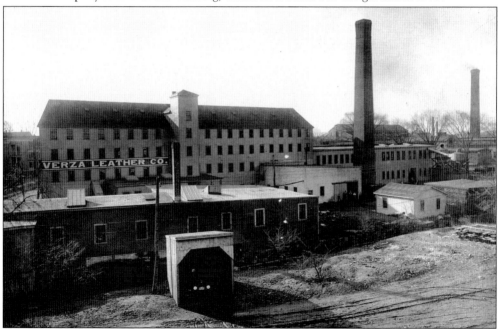

The Verza Tanning Company, located at 107 Foster Street, was first established in June 1914 by Louis Verza. It took over the old Charles F. Bushby lot, which consisted of 50,000 square feet of land.

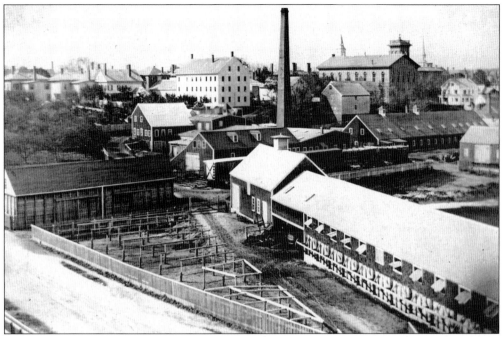

The image of the Pendar and Brown Leather Company, shown above around 1865, was taken from the main plant at Caller and Walnut Streets, looking southwesterly. The image below is the Pendar and Brown Leather Company's main plant, taken from the other side of the street looking northeasterly around 1870. The company changed hands over the years and was once called Brown and Caller and also Brown and Stanley. Owners of the company were Otis Brown and Frank Stanley.

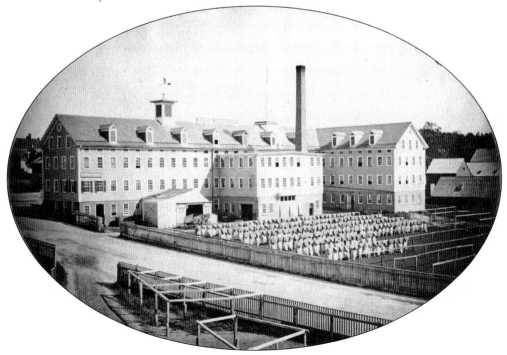

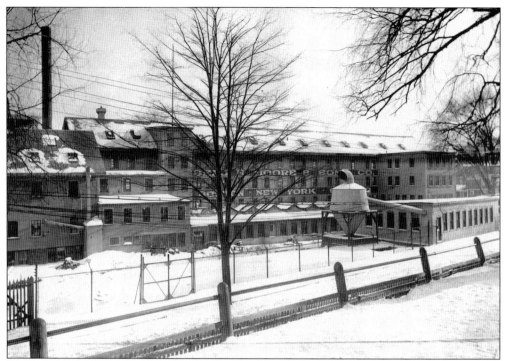

The Benjamin N. Moore and Son company was located on Pierpont Street. The company was first on Main Street in 1889 and incorporated in 1906 and relocated to Pierpont Street.

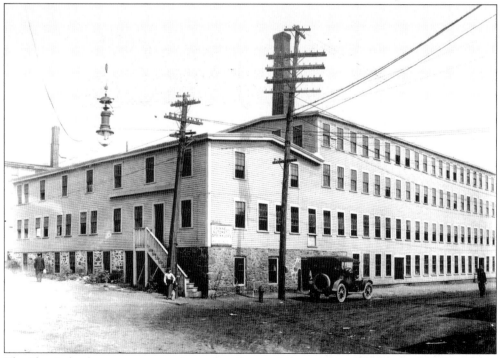

The Phenix leather company was located at the northeast corner of Walnut and Wallis Street, today it is this site of Travel Leather Company, the last leather company in Peabody.

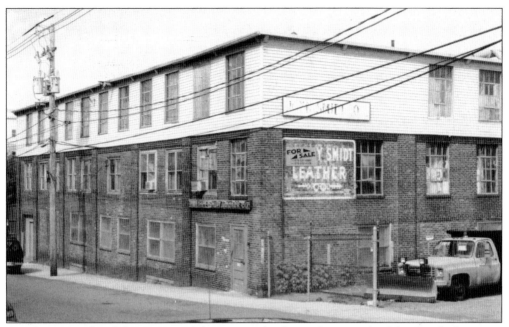

Another example of the victims of the waning leather industry is the John Smidt Company and Phenny Smidt Leather Company seen here. The building survived the May 10, 1984, fire at the Henry Leather Company, located next door, but went out of business soon after. The building laid empty for years until recently renovated and, like many other tanneries, made into housing.

Bob-Kat leather was one of the last few leather shops in town, before closing up in the 1990s.

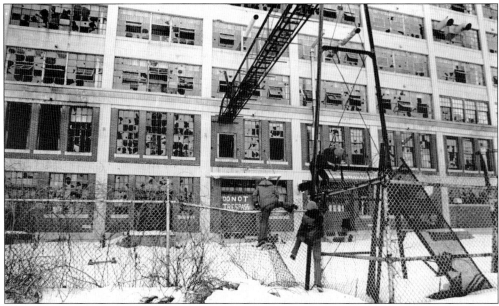

The 1970s saw the decline of the leather industry and factories were vacated after the companies left for lower-wage countries. The companies also left because of the increasing state and federal environmental laws. When the A. C. Lawrence Leather Company finally closed, its property fell into the hands of vandals before finally being converted into housing. Four of the brick and concrete buildings were revitalized and are still apartments today. Two new buildings have been added to the property and are condominiums called Peabody Crossing. The old Crowninshield mansion, built in 1813, is also still standing.

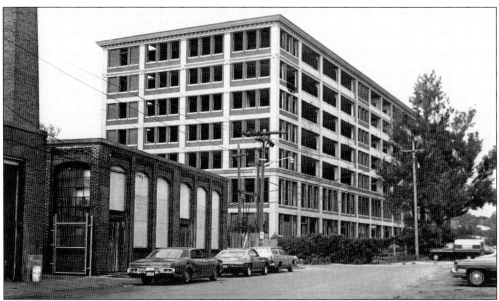

The administration building built in 1912, commonly referred to as the Q building, besides being offices was also used for the storage of tanning materials, storage of leather, finishing, sorting, and embossing. This seven-story building, with a basement, is located at 12 Crowninshield Street and today is housing for the elderly.

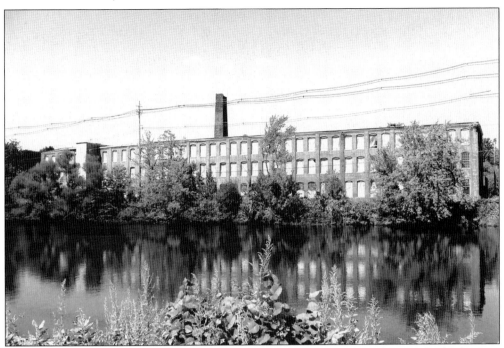

This location, Lynnfield Street, was the site of many businesses throughout Peabody's history, starting with Craig's Mill, then Vaughn, then Turner Tanning Machine, and a few felt and hair companies like American Felt and Densten Hair.

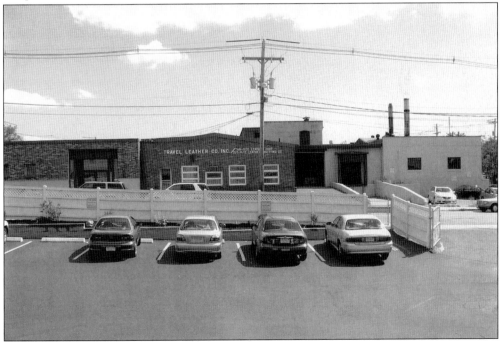

Travel Leather, also known as Cut-Rite or Tan Rite, is the only leather company still working in Peabody. It is still family owned and operated, by the Orgettas family, in the building that was once the site of Kirstein Leather and Phenix Leather.

The waning of the leather industry is Peabody is just about complete with only two leather establishments conducting business in Peabody. George "Butch" Cokorogianis and Charles Halepakis, owners of M. K. and Sons Express, transport chemicals weekly to Irving Tanning in Hartland, Maine, and return with loads of blue chromed tan hides. These hides are exported overseas and some of them are trucked to the last leather shop in Peabody, Travel Leather. Cokorogianis and Halepakis were also founders and co-owners of the former Leather Trim Company, located at the same site of their current business. Some of the last of the blue hides being unload from the truck at M. K. and Sons Express on Lynnfield Street are seen below.

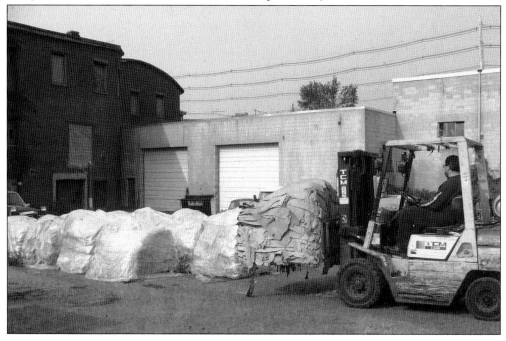

Four

THE LAWRENCE LEGACY

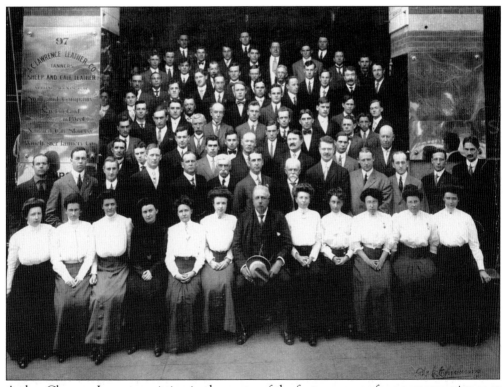

Arthur Clarence Lawrence, sitting in the center of the first row, poses for a company picture at the business office at 95–97 South Street in Boston.

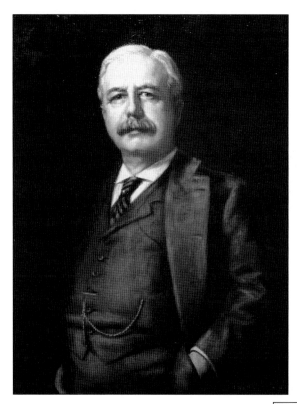

Arthur Clarence Lawrence was born in Maine, but moved to Boston as a young man. He apprenticed in the leather firm of Joseph Fields in Boston and became a partner in the firm some years later. He had also married the boss's daughter. Lawrence, the shrewd businessman, purchased land and buildings from the Sanger Glue company and the Blaney leather company, both in Peabody. With his first success in sheepskin he built more buildings.

Horace Austin Southwick's reputation, whose family had been in the leather industry for over 100 years, extended all over the country. First associated with his brother in the L. B. Southwick leather company, Horace then partnered with Lawrence as a cofounder of the mammoth A. C. Lawrence Leather Company.

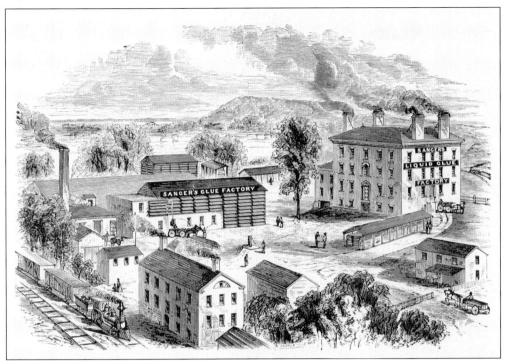

When A. C. Lawrence came to town in 1894 one of the purchases was the land the Sanger liquid glue factory occupied on the old Crowninshield property.

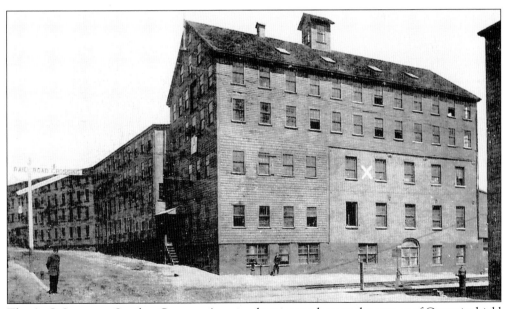

The A. C. Lawrence Leather Company's main plant is seen here at the corner of Crowninshield Street and Railroad Avenue. The three-story brick section of the building on the right side is the location of the original plant.

The Waters River Plant of the A. C. Lawrence Leather Company was the location of its patent leather factory. It was built around 1906 and was located on Pulaski Street, formerly Liberty Street. The plant consisted of 7 large and 13 small buildings. The buildings now are occupied by numerous businesses. The patent leather plant at one time produced enough patent leather to make six million shoes annually.

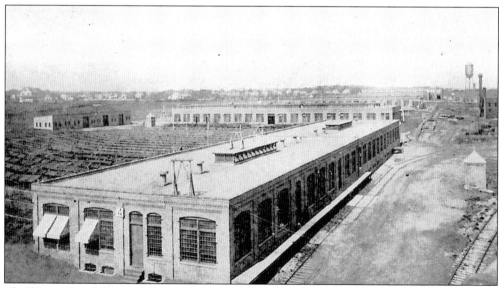

The Waters River Plant of the A. C. Lawrence Leather Company shows the new home of the Black Diamond. The picture above is also part of the Waters River Plant also and shows the building that was used for the first coat of the patent leather process. It was also called the Japan Works because they used Japan solvents. This plant was located on Pulaski Street, formerly Liberty Street. Note the leather hides drying in the sun. When it rained there was a big hustle to get the hides inside.

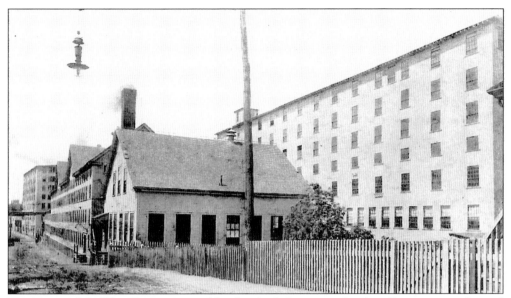

The National Calfskin Factory, owned by the A. C. Lawrence Leather Company, was located on Webster Street.

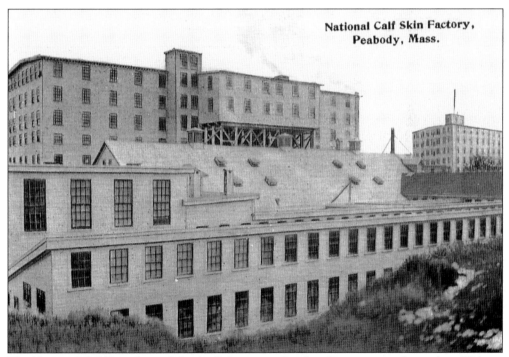

The National Calfskin plant of the A. C. Lawrence Leather Company was located on Webster Street on land once occupied by Thomas E. Proctor tanning, A. B. Clark sheepskin, and the Richard Young leather company. Some of the buildings are now occupied by many businesses and are also used for storage.

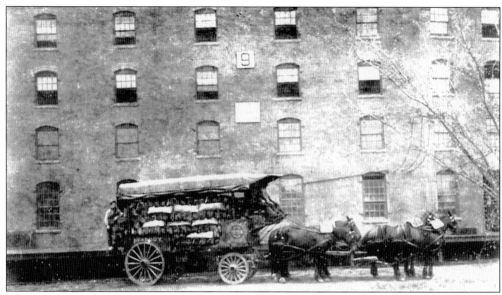

A teamster and his wagon are seen here posing in front of building No. 9 of the A. C. Lawrence Leather Company's "Hub" pigskin tannery with a load of hub strips that are bound for Lynn.

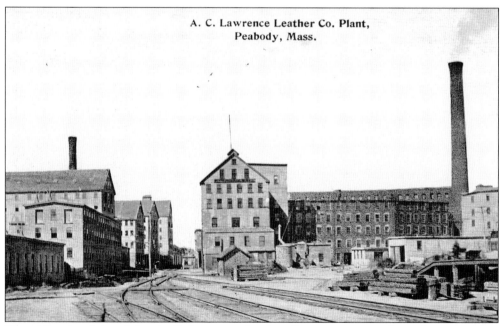

The old main plant of the A. C. Lawrence Leather Company is seen here, facing west on Railroad Avenue.

Seen here is the boiler house, or engine house, of the A. C. Lawrence Leather Company on Crowninshield Street, all that remains today of the house is the smokestack, seen below.

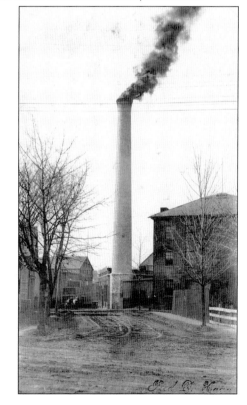

These smoke stacks, which towered up from the engine house of the A. C. Lawrence plant on Crowinsheild Street, worked day and night to serve the plants needs. They also served the needs of the city. Up until the 1950s, after 4:00 p.m. the engine house would provide 50 percent of the electricity in Peabody.

The cooling pipes in Crowninshield Pond, from the engine houses of the Peabody Electric Light and the A. C. Lawrence Leather Company, are seen here.

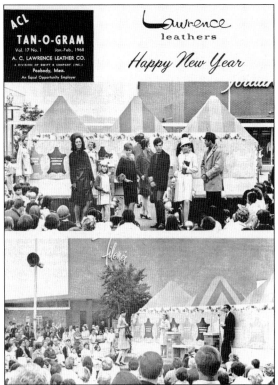

Tan-O-Gram was a bimonthly newsletter dedicated to the workers of the A. C. Lawrence Leather Company. It contained information about the company, employees, safety, jobs, and of course who won the sports games that were played those months. Plants would play against one another and there was great rivalry.

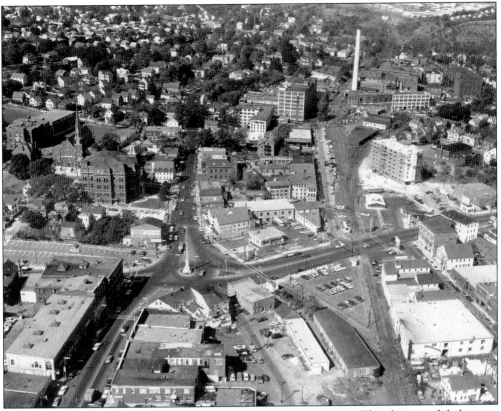

The photograph above was taken sometime in the mid- to late 1960s. The photograph below was taken in 2004. The difference in the landscape can be seen over those 40 years.

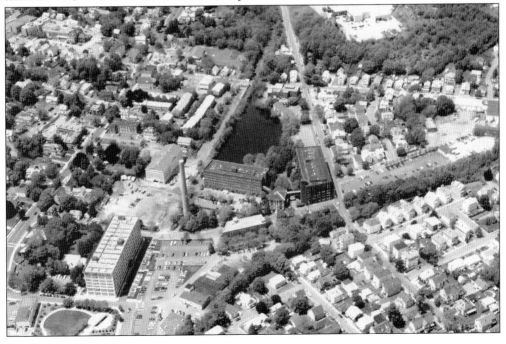

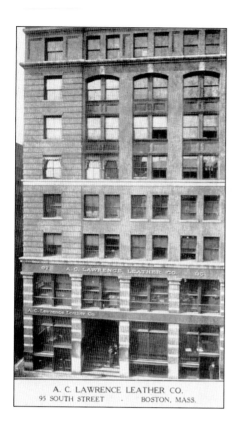

A. C. LAWRENCE LEATHER CO.
95 SOUTH STREET · BOSTON, MASS.

The offices of the A. C. Lawrence Leather Company are seen here at 95–97 South Street in Boston.

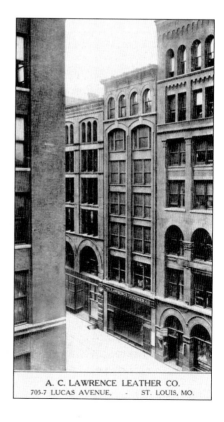

A. C. LAWRENCE LEATHER CO.
705-7 LUCAS AVENUE, · ST. LOUIS, MO.

The offices of the A. C. Lawrence Leather Company are seen here at 705–707 Lucas Avenue in St. Louis, Missouri.

The offices of the A. C. Lawrence Leather Company are seen here at 50 South Main Street, Gloversville, New York.

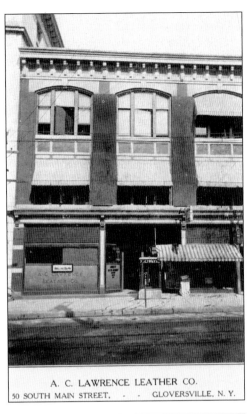

A. C. LAWRENCE LEATHER CO.
50 SOUTH MAIN STREET, - - GLOVERSVILLE, N. Y.

The offices of the A. C. Lawrence Leather Company are seen here at 632 Sycamore Street, Cincinnati, Ohio.

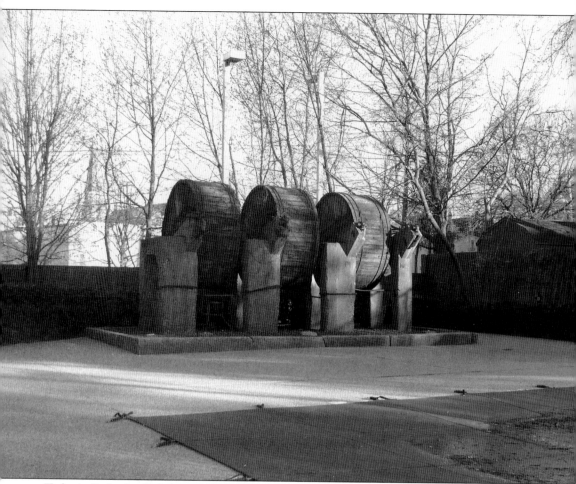

Today in Peabody, all that remains of the A. C. Lawrence Leather Company are the few buildings scattered around the city that are being used as other businesses. As for the main complex at Crowninshield Street, one would not know that the area was once the number one manufacturer of sheepskins and Peabody's biggest employer, except for these old tanning wheels, poolside at 12 Crowninshield Street. The A. C. Lawrence Leather Company, with factories in places other than Peabody like, New York, Maine, New Hampshire, Kentucky, and so on, and offices in Boston, New York, Ohio, Missouri, and other places around the country and the world, is gone but not forgotten by the people who worked there or by the people who remember the sights and sounds of the leather industry and the vastness of the A. C. Lawrence Leather Company.

Five

THE FACE OF LEATHER

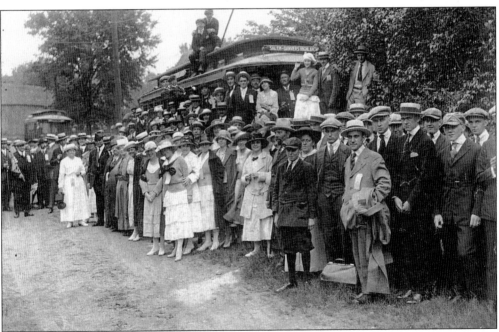

"Some Picnic" was the headline in an A. C. Lawrence company newsletter about a Saturday outing of the superintendents, foremen, office workers, and salesmen of the A. C. Lawrence company and the National Calfskin Companies at Centennial Grove. The outing was held on August 10, 1918, with over 800 picnickers enjoying a day of baseball, music, and dancing. It took 10 trolleys and many automobiles to get them there and it was stated that the parking "resembled Fenway Park during a World Series." Ironically it was 1918 when the Red Sox last won a World Series; that was until the "curse" was reversed when they won the 2004 championship.

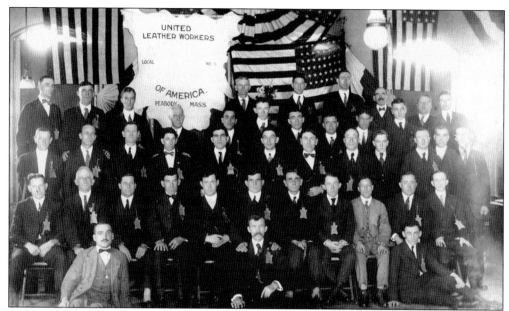

Members of the United Leather Workers (ULW) Local No. 1 posed for a photograph in September 1918. Peabody's main labor organization, Local No. 1, met every second Thursday at 7 Central Street at its union hall. Note their badges; they are in the shape of a leather hide. The ULW merged with the International Fur and Leather Worker Union, which was organized on June 16, 1913, sometime around 1933. They were associated with the American Federation of Labor (AFL), but left and joined the newly formed Congress of Industrial Organization (CIO), but were expelled by the CIO in the 1950s. In 1955, after the turbulent years of McCarthyism, the union again merged, this time with the Amalgamated Butchers and Meat Cutter Association of North America.

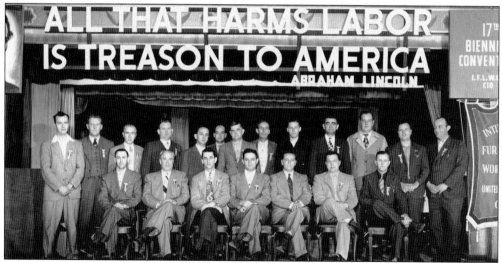

Union officials such as William "Dinny" Coughlin, fourth from the left in the second row, and president Michael O'Keefe, third from the left in the first row, worked arduously to achieve the best pay and working conditions for their brother workers and are pictured here with their fellow delegates of Local No. 21, at the 17th Biennial Convention of the International Fur and Leather Workers Union of the United States and Canada. This picture was taken at the Steel Pier in Atlantic City, New Jersey, in May 1948.

These men are tacking the skins to boards so they can be put in the dyer.

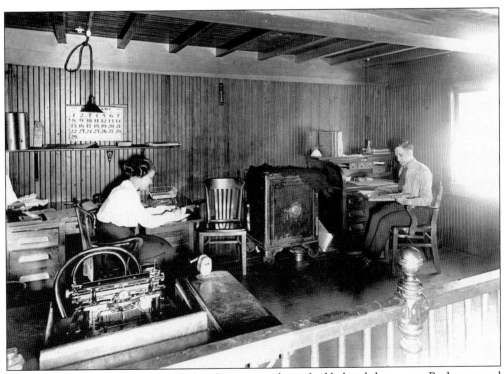

Like any business, an office is needed and many people worked behind the scenes. Both men and women worked in the office.

Louis Verza, far right, owner of the Verza Tanning Company, is pictured here with John Gorvers and Walter Isenberg.

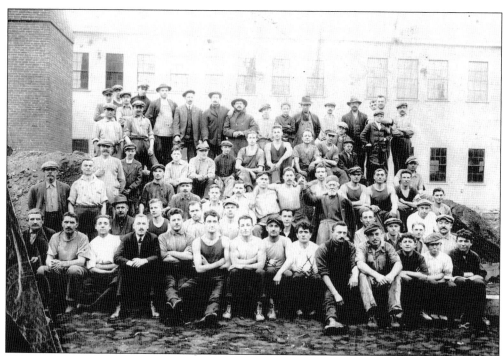

The crew of Verza Tanning is outside for a group photograph in the early part of the 20th century.

A crew from the Agoos leather company stops for a moment for a photograph, as did a group of workers from the Hunt-Rankin Leather Company. The Agoos leather company was originally a Lynn-based company. In the fall of 1926, Agoos took over the American Hide and Leather Company, which was the old Thomas H. O'Shea factory on Main Street. Hunt-Rankin was another large company, located on Summit Street in South Peabody, which is now the location of the Summit Industrial Park.

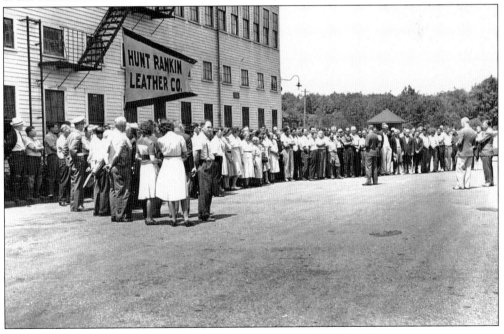

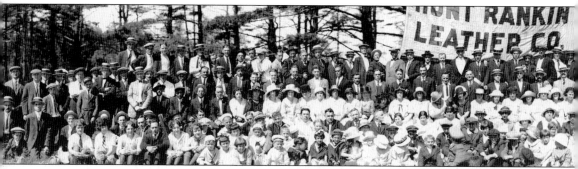

Annual and seasonal outings of the leather companies, such as seen in these images of the Hunt-Rankin Leather Company, were long awaited and highly anticipated days of mirth, merriment, and tomfoolery. Days of relaxation, in an industry and world filled with native and immigrant workers toiling arduously and plodding through the drawn out workweeks, revitalized

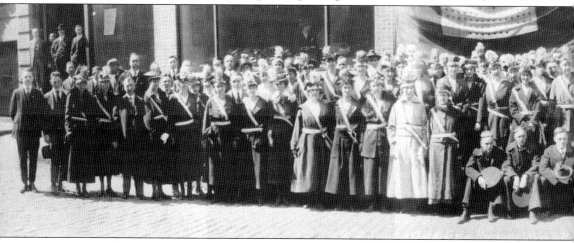

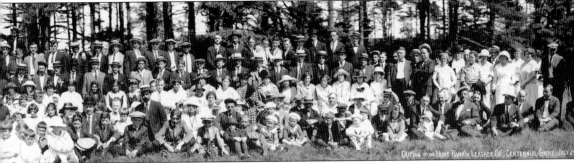

Outing of the Hunt Rankin Leather Co., Centennial Grove, July 2[?]

this dedicated and steadfast generation. The top image is from the Centennial Grove outing in Peabody on July 29, 1922, and the image below was taken at the A. C. Lawrence office in Boston for a Third Liberty Loan drive during World War I. "To make the world a decent place to live in, do your part," was the slogan of the Third Liberty Loan.

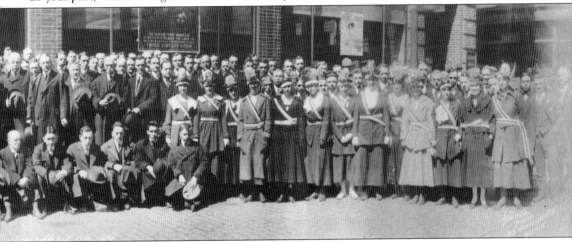

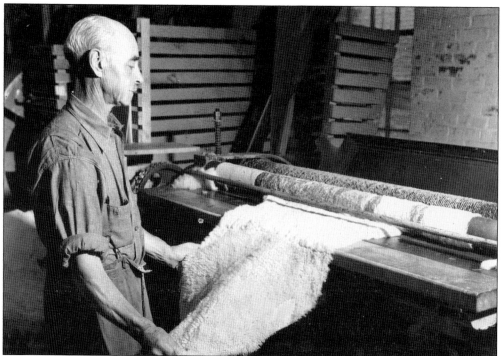

Shearling, sheepskin with the wool still attached, is being fed through a combing machine at A. C. Lawrence Leather Company to attain the desired nap sought after in a customer's specifications.

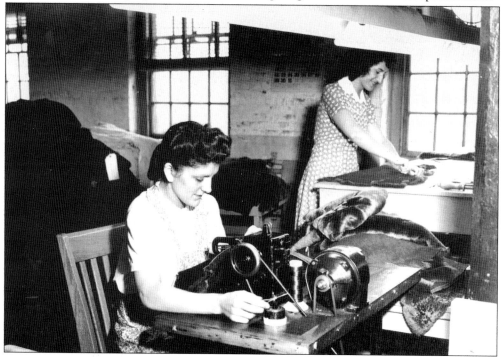

Miss Sakalakis is seen here sewing the shearling to create a larger salable piece, while another woman is trimming another one.

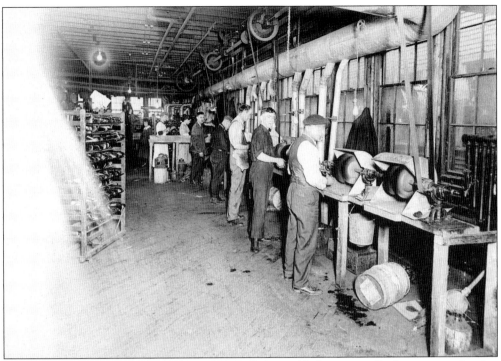

The factory of Strauss tanning is shown here with limited lighting, usually there were only a few bulbs strategically strewn about.

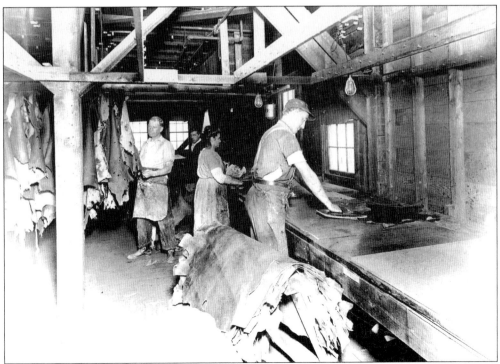

A hand grainer is working a curved piece of wood and would work the leather onto itself.

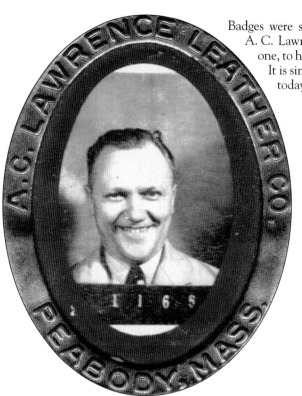

Badges were sometimes given to employees of the A. C. Lawrence Leather Company, such as this one, to help identify people during rough times. It is similar to the bar coded plastic badges of today, albeit not as ornate as this one.

Patriotic Flag Day Exercises

Auspices of the

Employees of Waters River Plant

of the A. C. Lawrence Leather Co.

Friday, June 14, 1918
12.30 P. M.

WATERS RIVER PLANT

The leather companies were very patriotic and would hold Flag Day exercises, parades, and liberty bond marches.

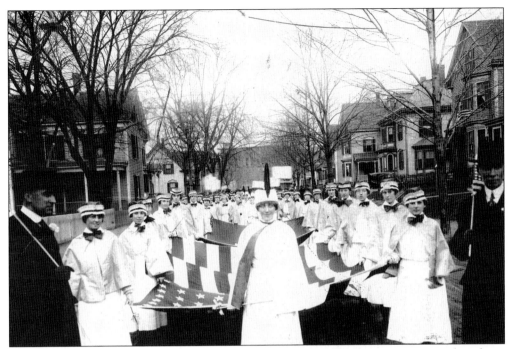

Women of a patriotic group from the A. C. Lawrence Leather Company are seen parading down Warren Street carrying a huge flag.

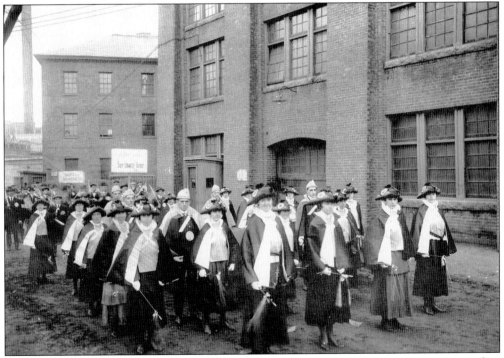

National Calfskin employees from the Webster Street factory show their patriotic spirit as they prepare to march down Warren Street in support of World War I liberty bonds. Notice the tricornered hats, flags, and scepters.

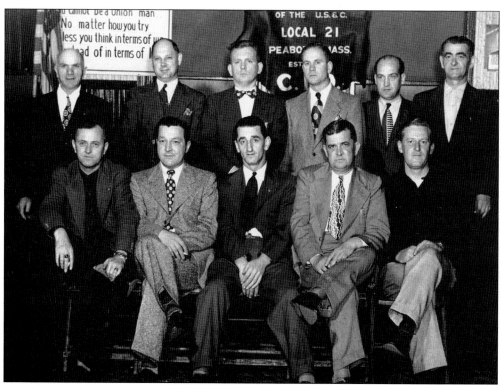

The executive officers of the International Fur and Leather Workers Union are seen at their hall on the third floor of the O'Shea building with an entrance on Foster Street. The bottom image was taken in April 1954.

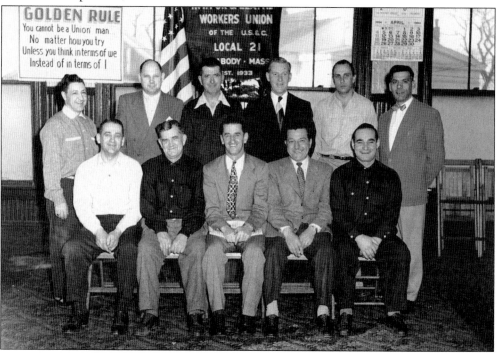

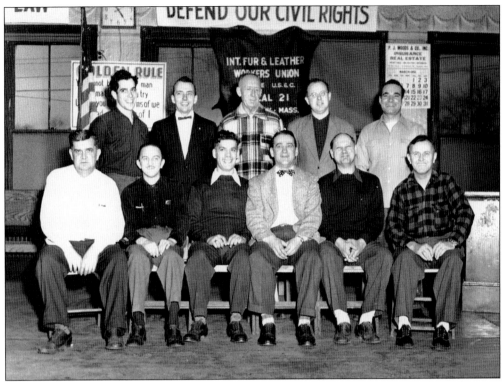

There is no *I* in *team* was one of the golden rules used a slogan of the union. Men shown here are union officials from the International Fur and Leather Workers Union, Local 21, of Peabody. The bottom image was taken after some kind of a vote in March 1948.

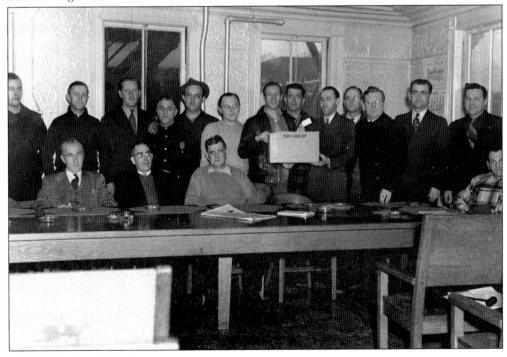

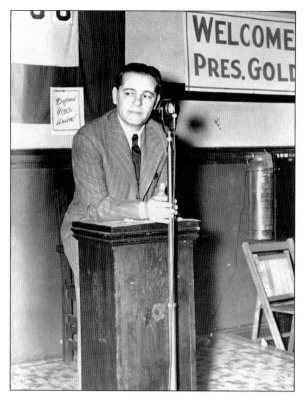

Ben Gold, a colorful character to say the least, became president of the International Fur and Leather Workers Union in May 1935. He was embroiled in controversy from the beginning and attracted attention as a rabble-rouser and had communist ties. He was brought up on charges in the 1950s during the McCarthyism era, also known as the Red Scare, and stood trial in *United States of America v. Ben Gold* and he ultimately was compelled to resign as president.

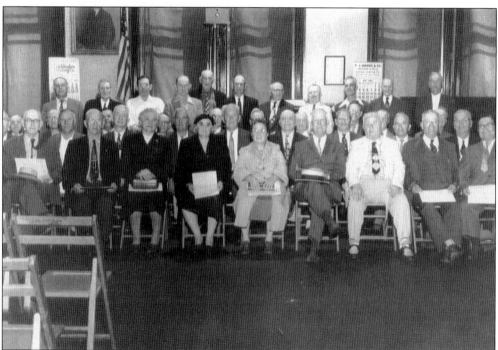

A group of union officials and workers was photographed in the council chambers of Peabody City Hall at some unknown event in May 1953.

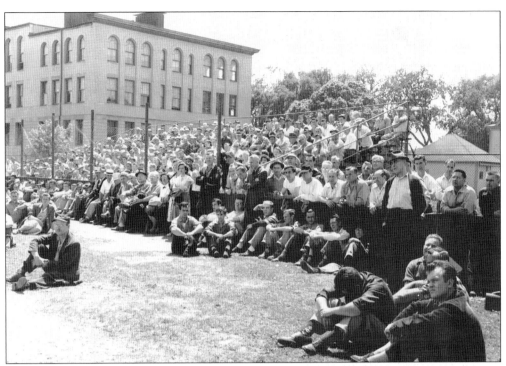

Sometimes in the nice weather, besides the intercompany and company sporting event, rallies would take place out behind the high school, like this one.

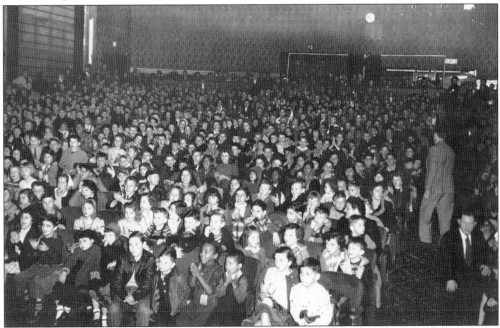

The Strand Theater was the setting for this party, quite possibly a Christmas party, for the children of the leather workers. William Patrick "Dinny" Coughlin used to play Santa Claus for the union's annual children's Christmas party. These events were sometimes held in a large hall or in the old Strand Theater as this image portrays.

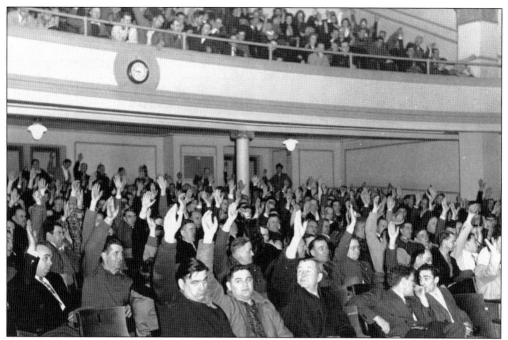

The "ayes" have it in these images of one of the many union votes that took place in large halls, because of the vast numbers of union workers, like city hall, or like this one at the Seeglitz auditorium when Peabody's high school was located at Central Street.

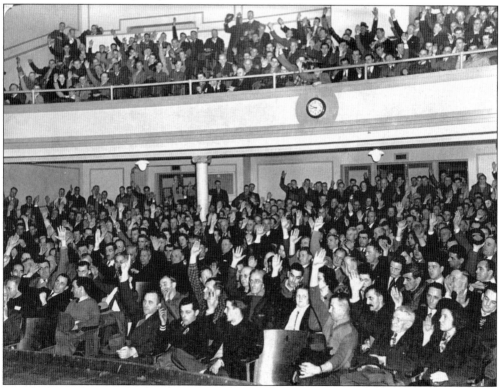

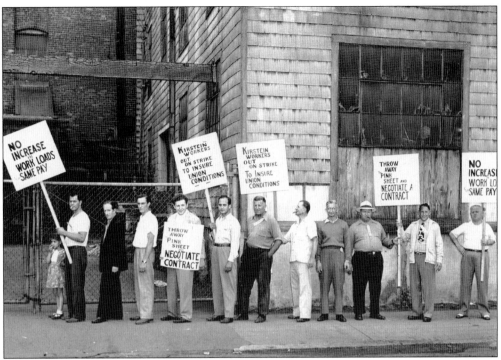

Signs say it all while Kirstein leather workers go on strike. Kirstein was located at the corner of Caller and Walnut Streets. It also had a factory at the northeast corner of Walnut and Wallis Streets. The leather industry, like all other industries, had its share of labor issues. The industry would have many strikes, some more significant than others. Local No. 1 of the ULW was born out of this in Peabody. Later the union would vote to merge with the International Fur and Leather Workers Union and become Local 21 of that union.

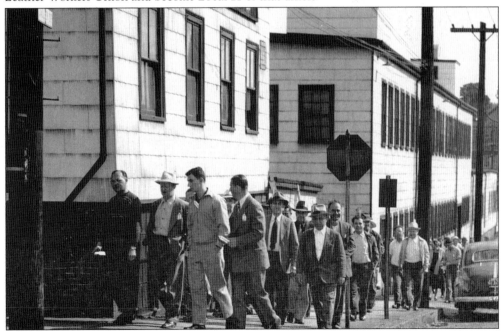

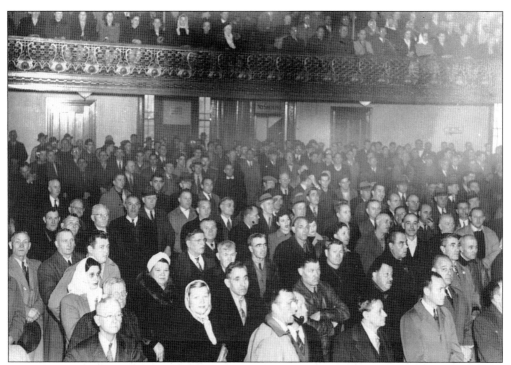

Votes were also taken at Peabody's city hall when it was needed because of the numerous amount of union members.

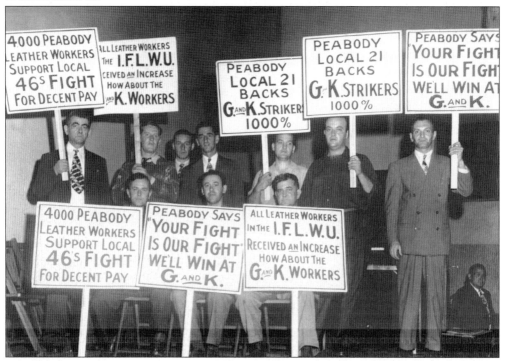

Members of Local 21 show their support of their brother leather workers. Local 46 was a Canadian local.

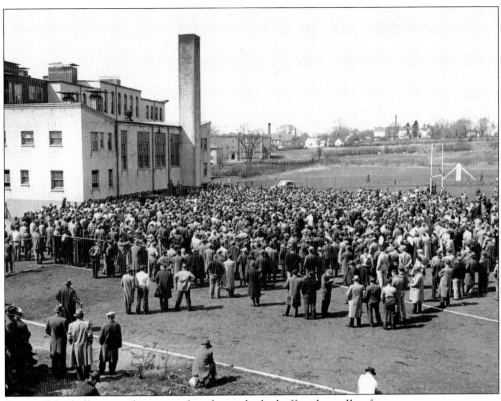

Some of the ball games that were played were kicked off with a rally of some type.

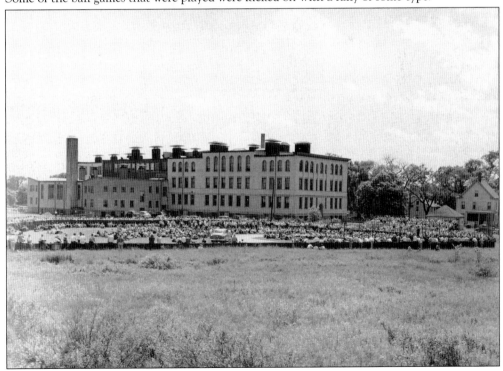

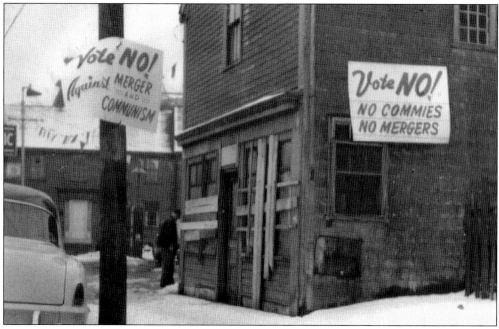

The Red Scare did not pass over Peabody, as shown in these images. Posters were displayed all over town. In a major antiunion campaign by the leather companies, with rallies and signs that were posted throughout the city, the Red Scare was in full swing. These signs were placed on an abandoned store on Lowell Street, next to the Ancient Order of Hibernians and the former Atlantic Gas station. Clem Feeny and A. Aiken are pictured in the image below.

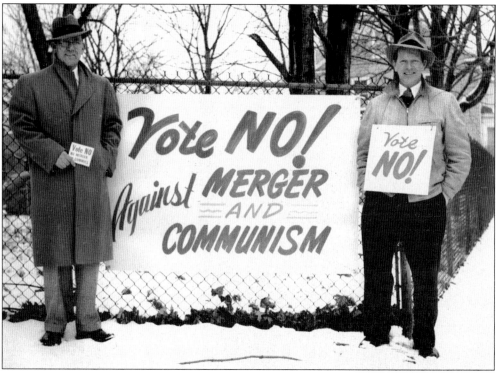

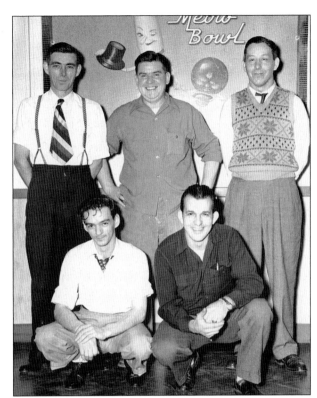

Whether it was bowling, baseball, basketball, or just out for a ride, the days off from the daily grind of the factories were well appreciated. In the image below, now at bat is Bobbie O'Connor.

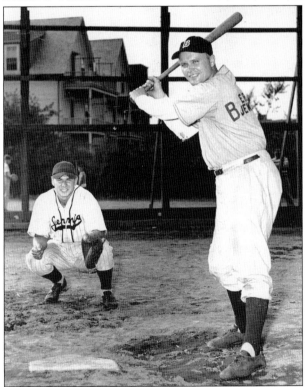

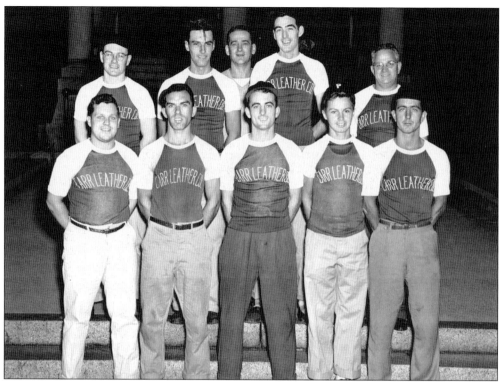

The boys of the Carr Leather baseball team pose in front of Peabody City Hall, as well as the boys of the Local 21 basketball team.

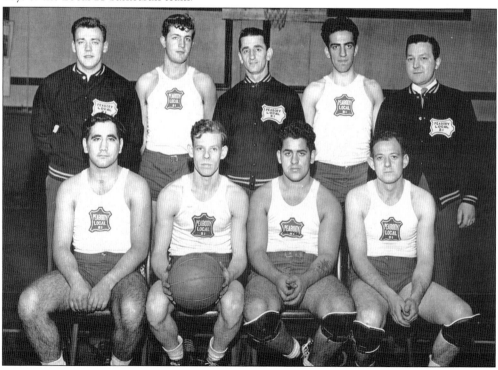

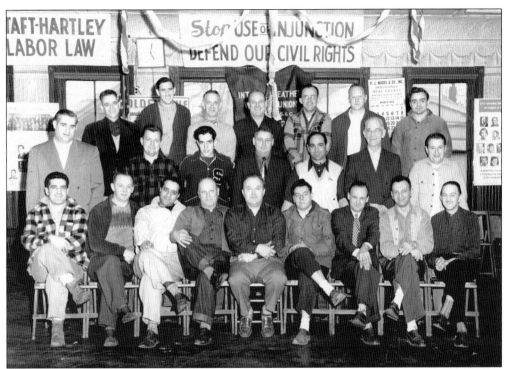

Seen here are photographs of the International Fur and Leather Workers Union Local No. 21 union officials in their union hall located on Foster Street. The top image was taken in March 1952 and the bottom image was taken in March 1954.

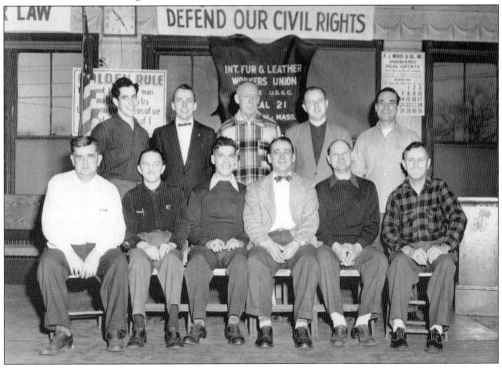

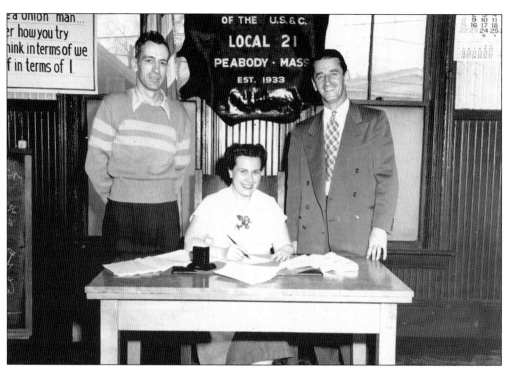

In the above photograph, the Local 21 elected officers are, from left to right, Tom Halinan, unidentified, and Michael O'Keefe, taken in February 1953. The bottom image was taken in March 1951.

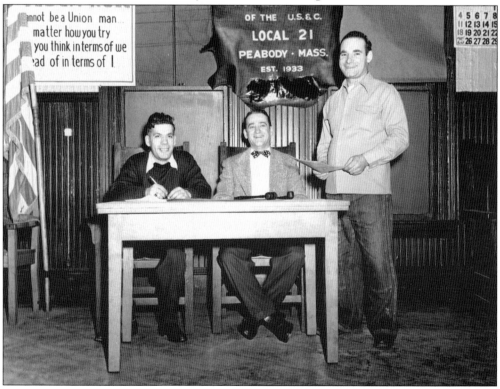

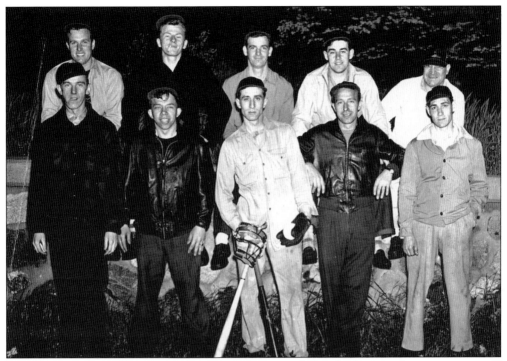

Whether it was a pick-up game of a few workers or a full-fledged team, the escape was well needed for the long hard hours of work these men endured. In the image above, in the second row, second from right is Walter Magesky and on the far left is Francis Clark.

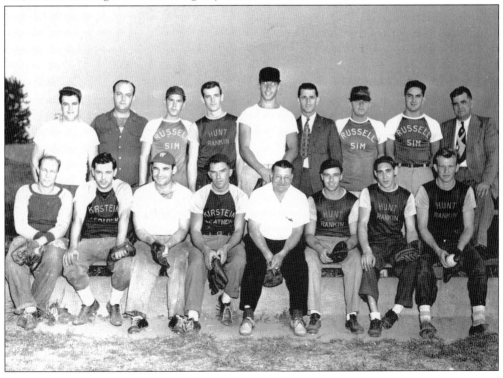

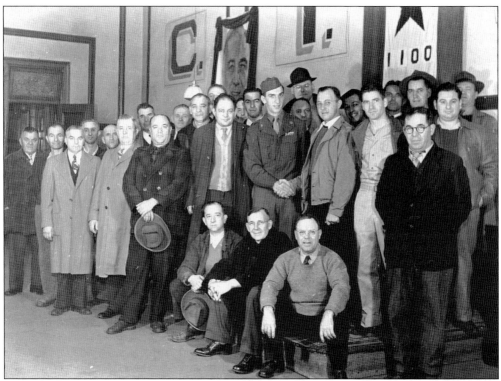

Whether it was to welcome home veterans or donate things, such as this Red Cross ambulance (below), the union took pride in the community and their workers. Notice, in the image above, the number 1100 that is accompanied by a red star, which told how many union members were in military service during World War II.

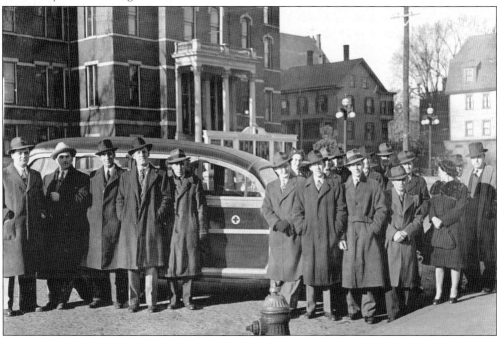

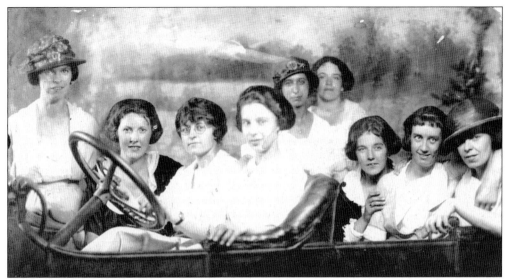

It is a girls' day out. This picture, taken at Revere Beach, shows, from left to right, friends Elizabeth Higgins, Susan Cox, Gertrude Holden, Blanche Southwick, Agnes Gorham, Beatrice Jeffers, Alli Pentilla, Julia Griffin, and Lillian Doyle enjoying their time off.

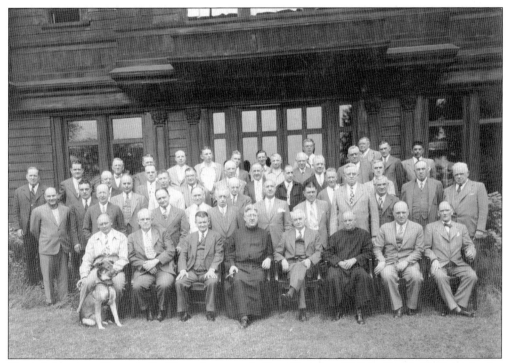

One of the many Tanners Guild conferences, held at Campion Hall in North Andover, in the 1940s is seen here. In the first row from left to right are Charles Heckel, Jack Callahan, Arthur Carr, an unidentified priest, Felix Carr, and three unidentified men. In the second row beginning at the right are former Peabody mayor J. Leo Sullivan, George Jones, an unidentified man, "Big Ed" Flynn, and the rest of the who's who of the leather industry of Massachusetts.

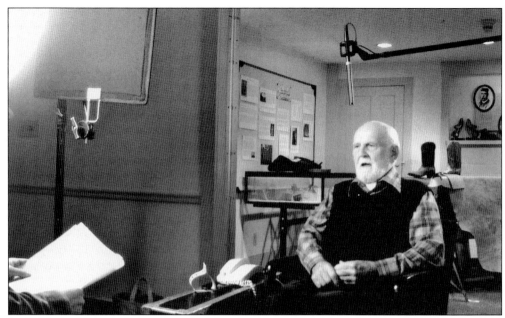

In 2005, the History Channel produced a documentary on the leather industry. It could not have been told correctly without Peabody being involved. Bob Quinn, retired docent of the George Peabody House, was interviewed for his knowledge and experience in the leather shops. Bob's son, Robert, was a coproducer and director of *Leather Soul*, a documentary on the leather industry in Peabody.

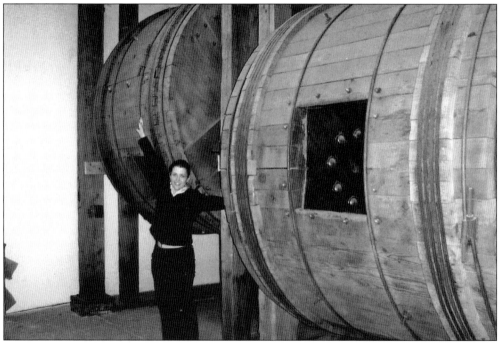

Marieke Van Damme, curator of the George Peabody House and Peabody Leatherworkers Museum, poses in front of a pair of tanning wheels at the old Rex Leather Company at 119 Foster Street. One can only image the size of the tanning wheels compared to Van Damme's stature.

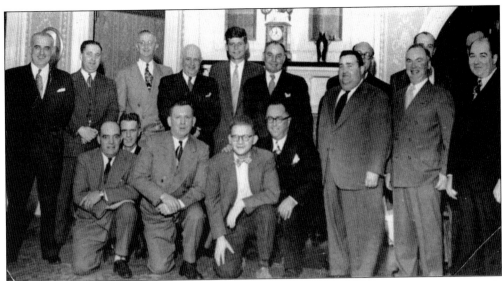

Seen here is a picture of men from Peabody and the leather industry taken in early March 1951 at the home of Thomas O'Shea, at the corner of Main and Washington Streets. From left to right are (first row) Jim Collins, Harold McDermott, William "Dinny" Coughlin, Thomas O'Shea Jr., Thomas O'Shea Sr., George Ankeles, Jim Kelleher, and Mack Morrisey; (second row) Leo Devlin, Ed Neenan, Horace Nelson, Mayor McGrath, then congressman John Fitzgerald Kennedy, Francis Collins, Jim McNamara, and two unidentified men. The thank-you letter at right was from Kennedy himself.

JOHN F. KENNEDY
11TH DIST., MASSACHUSETTS

COMMITTEES:
EDUCATION AND LABOR
DISTRICT OF COLUMBIA

Congress of the United States
House of Representatives
Washington, D. C.

1702 Federal Building
Boston 9, Massachusetts
March 16, 1951

Mr. William Coughlin
31 Aborn Street
Peabody, Massachusetts

Dear Bill:

It was nice meeting and talking with you at the home of Mr. and Mrs. O'Shea last Sunday morning.

I appreciate your interest and hope to see you again in the near future.

Sincerely,

John F. Kennedy

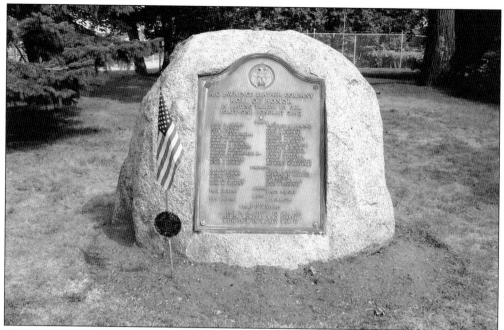

This rock monument, located at the corner of Lowell and Crowninshield Streets, was dedicated to the World War II veterans of the A. C. Lawrence Leather Company. Forty-four A. C. Lawrence workers were killed during World War II, with 26 from Peabody. An additional 1,038 workers also served in the military during the war.

The inscription on the Leather City Commons monument is as follows, "As an oak leaf from this common floats down Proctor Brook to the sea, so we here commemorate, for all the world, the labors of our forebears, our neighbor, and our friends. They built a city as strong, as diverse, and as enduring as the leather they made. Let their toil in shaping this community and in supporting the hopes and dreams of future generations be remembered, now and always."

Six

THE FIRES

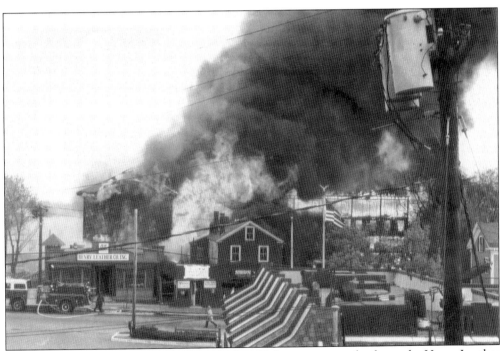

One of the worst fires to hit Peabody in the late 20th century was the fire at the Henry Leather company on Main Street on May 10, 1985. It is mostly remembered as the May 10 fire, for obvious reasons. At 9:30 a.m. an explosion rocked the city, sending flames reaching 200 feet into the morning sky followed by thick, black bellowing smoke.

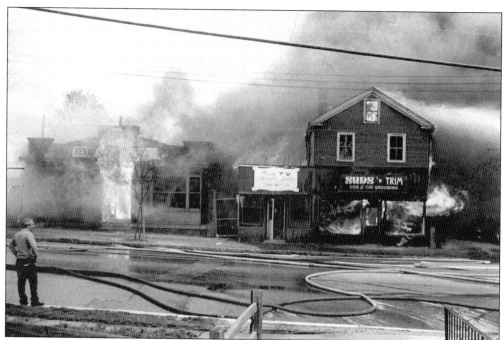

Located across from McDonald's restaurant on Main Street, the Henry Leather building and surrounding buildings were a densely packed complex of leather shops, chemical, and other businesses. The fire raged all day, and with the assistance of 37 engines, 10 ladder trucks, and 2 foam trucks for fighting airplane fires, the conflagration was finally quelled.

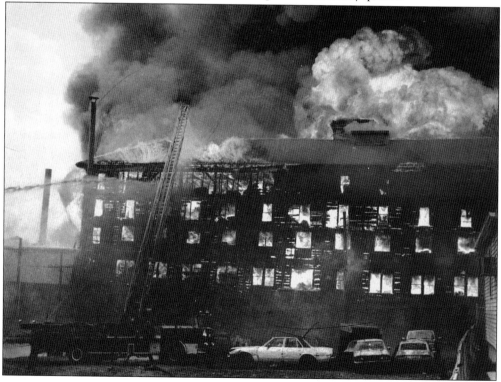

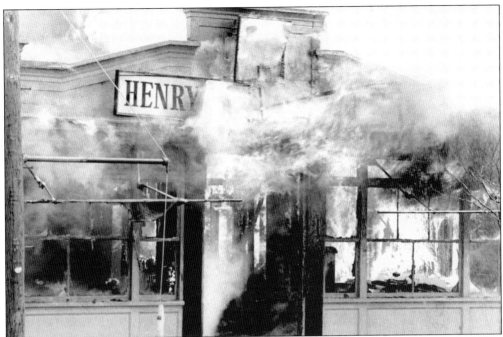

The fire was caused by a welder's torch. The welder was the only fatality that day, miraculously. When all was said and done, the total loss from the fire was in the tens of millions of dollars. Losses from the fire included 19 businesses, 300 jobs, and 27 motor vehicles, as well as having a major environmental impact.

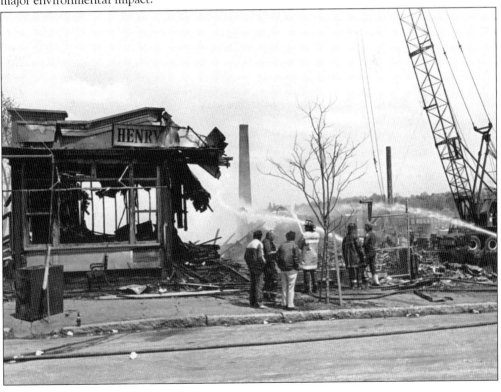

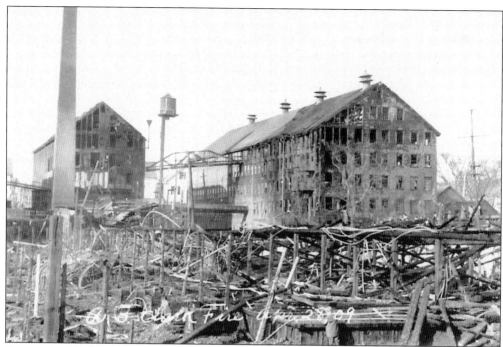

On a rainy April 28, 1909, a fire broke out at the A. B. Clark sheepskin factory. Although the rain helped stop the further spread of the flames, the damage caused by the fire was at the time the largest to date with the loss valued at over $300,000. Not much remains after the fire ripped through the old factory with its long open spaces and chemical-soaked floors. The location of the Clark factory was 4 Union Street. It was the former home of the Thomas E. Proctor leather company.

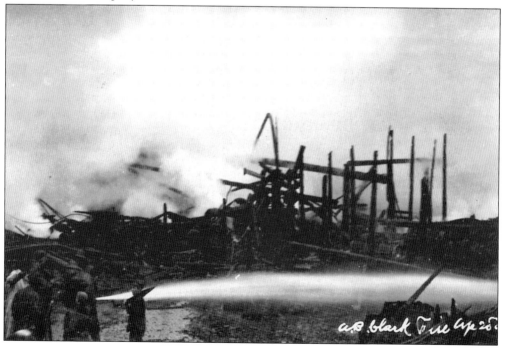

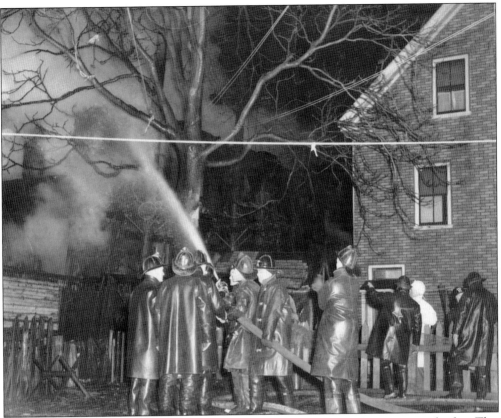

On January 19, 1950, the Hogan Tanning Company, at 16 Hancock Street, caught fire. This building was nestled in between houses in the residential neighborhood and firemen had a tough time keeping the flames from spreading to nearby homes.

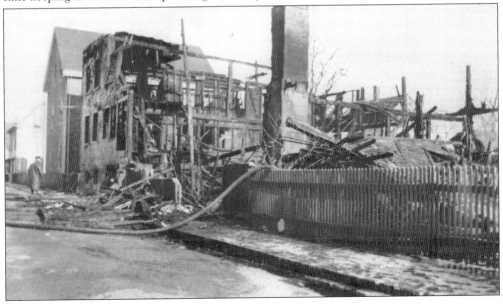

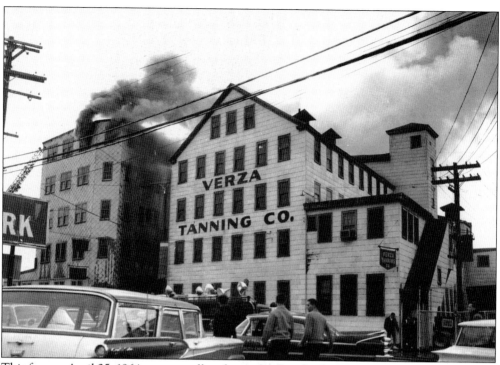

This fire, on April 25, 1964, was actually a fire at the Carr leather company at 111 Foster Street, located next to the Verza Tanning Company at 107 Foster Street.

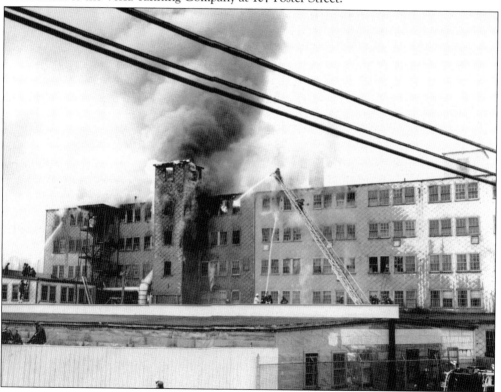

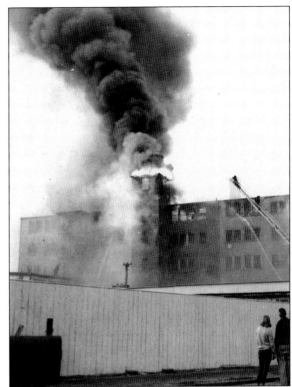

The construction of these wooden buildings—the open space and the chemical-soaked floors and shafts, such as the elevator shaft seen here on fire—proved no match for the fire, even with a fire department of the highest caliber, the Peabody Fire Department.

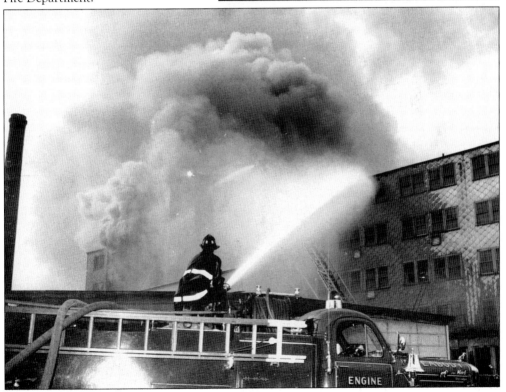

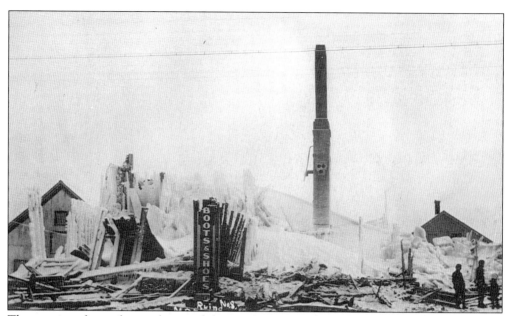

The remains of an unknown boot and shoes company are shown here after a devastating fire in the middle of the winter months.

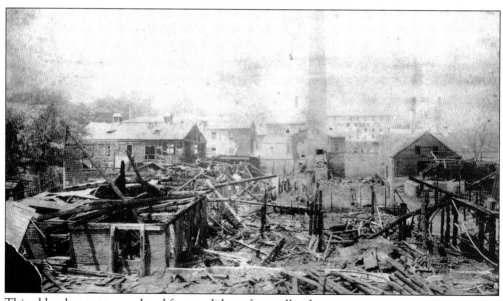

This old unknown tanyard and factory did not fare well either.

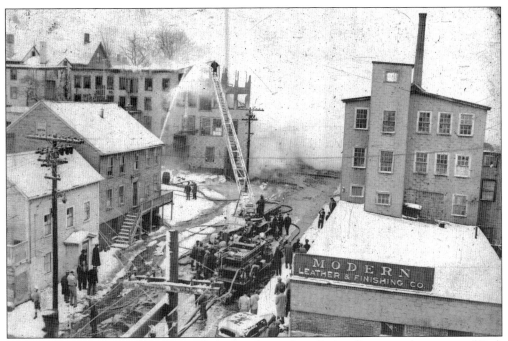

The Modern Leather and Finishing Company, located on Spring Street, at the corner of Park Street, had seen its share of fires, including this one on January 7, 1952.

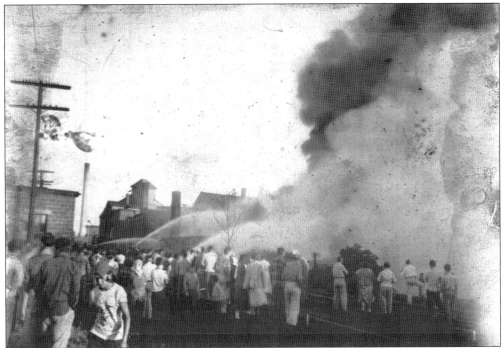

This picture was taken from the rear of the Salwin Leather Company, on the railroad track, on August 4, 1951. The Salwin Leather Company was located on Walnut Street and was located next to M. W. Ellis Grain Company. The loss from the fire caused $300,000 to $500,000 worth of damage and put many people out of work.

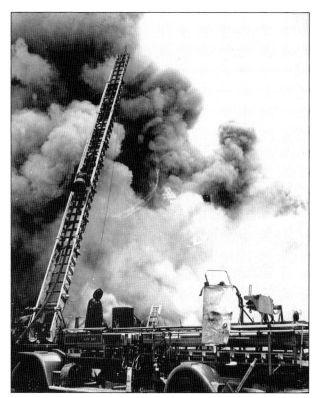

Korn Leather Company, owned by Max and Rhoda Korn, is seen here on fire. It was located on Walnut Street. The Korns relocated to Peabody after losing property to the great Salem fire of 1914.

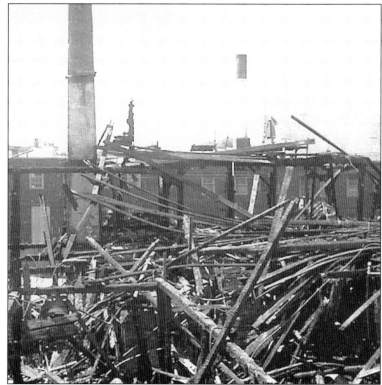

These are the skeletal remains of the Coronet Leather Company on Spring Street from a fire that took place on July 24, 1976.

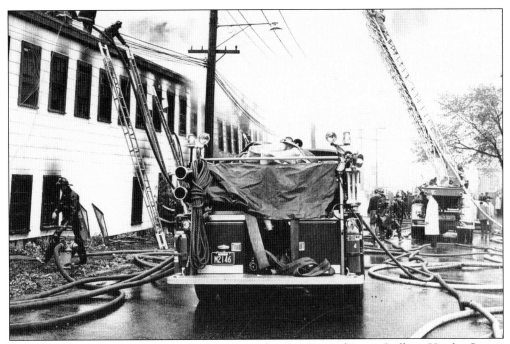

On May 14, 1964, in a leather factory owned by John Gnecco and Louis Grilk on Howley Street, five men lost their lives in a fire that was caused by an explosion from an acetylene torch and volatile vapor. Three of the five men killed had only been in this country for less than four years and worked for the Gnecco and Grilk tanning company. The other two men, Paul A. Caron, age 22, and B. Robert Conway, age 30, were employed by the Larrabee-Hingston Company and were working on a tanning drum in the basement. In the image below, St. Thomas Church on Margin Street in Peabody was the scene of the triple funeral for the three Portuguese American workers who perished in the inferno—Jose Carvalho, age 30, Anthony Silva, age 56, and John Vierra, age 51.

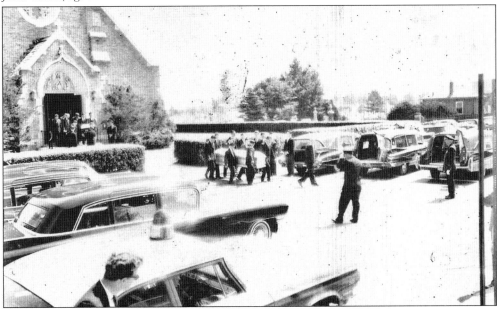

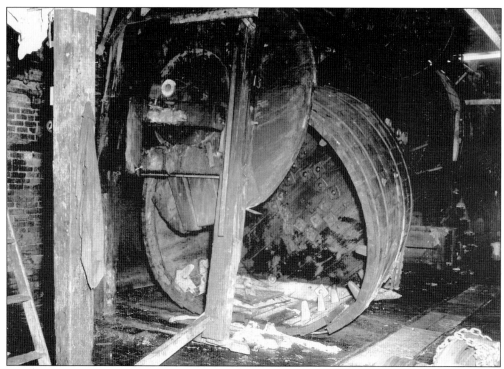

Some fires were kept in check, like this one at a tanning wheel, and some were not, like the previous images.

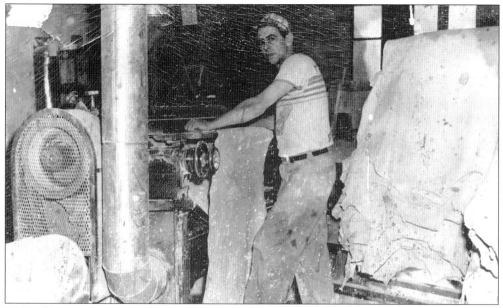

The buffing machines caused a lot of dust, which was collected in a "buffing box." If there was a tack left in the hide, or anything that would cause a spark, it would ignite the buffing dust and cause a fire in the buffing box. Many a fire had started there and many a fire had ended there, or else one would have to contend with a conflagration if it got out of control. Frank Conway is seen here working on a Curtin-Hebert 54-inch oscillating buffing machine built in 1912.

Some fires were actually ignited with noble intent, like these barrels that were assembled for bonfires to light up the midnight skies during the Fourth of July celebrations at various parks in and around Peabody. Theses barrels were used to hold pickled skins, as well as chemicals and dyes, and were used, leftover, or damaged. What started out as meager pyramids of approximately 100 hogsheads, or barrels, grew into architectural feats all their own, eventually showcasing monstrous obelisks of over 1,000 barrels towering an incredible 100 feet skyward. In 1926, one such towering tier of timber collapsed, sending six boys that were laboring on it to the local hospital with serious but not life-threatening injuries. Peabody's bonfires were usually put on by the East End Friscoes, an athletic club, and were lit by a long wick that started the fire at the top.

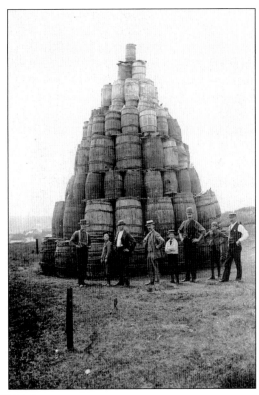

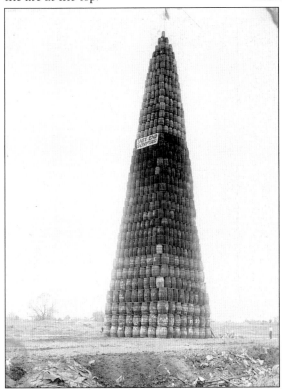

ACROSS AMERICA, PEOPLE ARE DISCOVERING SOMETHING WONDERFUL. *THEIR HERITAGE.*

Arcadia Publishing is the leading local history publisher in the United States. With more than 3,000 titles in print and hundreds of new titles released every year, Arcadia has extensive specialized experience chronicling the history of communities and celebrating America's hidden stories, bringing to life the people, places, and events from the past. To discover the history of other communities across the nation, please visit:

www.arcadiapublishing.com

Customized search tools allow you to find regional history books about the town where you grew up, the cities where your friends and family live, the town where your parents met, or even that retirement spot you've been dreaming about.